Education Dilemma
in Malaysia

Education Dilemma in Malaysia

Past, Present and Future

JEFF TONG

PARTRIDGE

A Penguin Random House Company

Library of Congress Control Number:		2014939159
ISBN:	Hardcover	978-1-4828-9886-6
	Softcover	978-1-4828-9885-9
	eBook	978-1-4828-9887-3

To order additional copies of this book, contact
Toll Free 800 101 2657 (Singapore)
Toll Free 1 800 81 7340 (Malaysia)
orders.singapore@partridgepublishing.com

www.partridgepublishing.com/singapore

Contents

To any parents who are concerned for their children's education

1

Preface

I extend my greetings to all enthusiastic readers and those who read my writings on the education dilemma in Malaysia. Personally, I would like to welcome readers all around the world. It does not matter if you are in the Eastern Hemisphere or Western society if you want to read this book. The intention of this book is to explain to citizens of the world about the problems faced by Malaysians in the national education system in my country.

Readers probably will compare the education scenario in your country to the education scenario in mine. Although each Malaysian has the opportunity to go to school, he or she has to deal with problems arising from the inefficiency of the education system due to overintervention by political institutions. Is it rational for political institutions to interfere with the education in Malaysia, a country that practices a parliamentary democracy system? Readers should consider that such scenarios should not happen in Malaysia, but instead in the communist countries such as China, North Korea, and Cuba. Readers may choose to agree or disagree with my opinion of the book. That depends on their personal discretion.

But there is one thing certain. Indeed, many problems have emerged in the Malaysian school system with the government still failing to overcome them. So in this book, I would like to discuss the problems in the Malaysian school system. Finally, I will suggest some effective solutions to them.

Hopefully, this book will create awareness to the world about how school systems in the third world, especially in Malaysia, are ineffective in human development. Hopefully, developed countries in Western society will contribute energy in helping a third-world education system to meet international standards. So happy reading.

2

A Brief History of Education in Malaysia

If we want to study the history of Malaysian education clearly, we have to start in the era of Majapahit and Srivijaya. At that time, society was not focusing on secular education. Instead, spiritual education was emphasized, especially Hindu religious teachings of Buddha. Children who came to pray at a Hindu and Buddhist temple usually attended religious classes at the same time. In religion class, children were taught using the book *Dhamarsutra*, the Buddhist scriptures. Religious institutions played an important role as universal education centers, attracting a Buddhist monk from China, *I Ching*, to study in Palembang, Sumatra. During that era, Palembang was a Buddhist preaching center. Buddhist religious texts were the central translation from Sanskrit to other languages. These translation activities facilitated the people of the region to deepen the studies of Buddhist-Hindu religion. It is believed that nearly the entire Malays Archipelago accepted the Hindu Buddhist influence during the golden age of the Srivijaya and Majapahit kingdoms.

In those days, religious education was considered formal education for the local community. Lack of emphasis was given to secular subjects, such as science, mathematics, and language. Children could learn some science, math, and philosophy in religious texts; however, knowledge of those subjects was not described in detail in religious texts. In most cases, children got informal education at home through homework. For example, parents taught their children how to farm, hunt, fish, and rear

animals. All lessons learned were related to life skills. The aim was to train children to live independently when they grew up. The golden age of Buddhism in the Malay Archipelago only lasted a few hundred years.

With Islam's entry into the Malay Archipelago, the people gradually accepted the religion. Islamic missionaries used a moderate approach to spread Islam in order to get a good reception from the Malay Archipelago population. Finally, some local governments such as Aceh, Melaka, and Jambi embraced Islam. When the government embraced Islam, locals embraced Islam. Aceh and Malacca became an important center of Islamic preaching in the fifteenth century. Muslim missionaries spread the religion to the colonies of the Malacca Empire, such as Sumatra and the Malay Peninsula. In addition, in this region the state also became a center of Islamic religious interpretation to facilitate people's understanding of Islam by using their native language.

The entry of Islam to the Malay Archipelago changed the region's tradition of education. More and more people in the region studied Islam. This knowledge became dominant knowledge in the Malay Archipelago. The golden era of Islam influence started in those days. Many mosques were erected for places of worship. They also turned into places for studying Islamic knowledge as pillars of Islam, Shariah, and Islamic theology.

To meet the needs of the growing population of Muslims, *madrasah* (religious schools) were built to formally provide religious education to children. For villages or remote areas with no religious institution, a school hut was built to provide education to the local children. Typically, religious teachers volunteered to teach children how to study and perform worship according to Islamic tenets.

Malacca fell to the conquering Portuguese in 1511. This incident ended the era of the Malacca sultanate. The functions of the mosque and *madrasah* as educational institutions were affected after the Portuguese conquered Malacca. However, these educational institutions remained in places that the Portuguese did not colonize. The Portuguese had authority

in the Malacca only. The whole Malay Peninsula and other parts of the empire such as Kedah, Perak, and Pahang were free from Portuguese colonization. Princes of the last sultan of Malacca had each set up a new government in the state of Johor and Perak. With the presence of the new government of Johor and Perak, the identity of Islamic educational institutions was still maintained.

After the Portuguese conquered Malacca, they brought in many Christian missionaries to spread the religion. Many missionary schools were founded to spread the religion as well as provide theological education to Christians—for example, Portuguese officers and their families. Mission schools also provided instruction in secular subjects, such as philosophy and Portuguese law. At first, the locals were not interested in this schooling because they feared being Christianized. Gradually, when more and more locals were professing the Christian faith, local residents accepted missionary schools as learning institutions for their children.

The Portuguese era ended with the Dutch occupation at Malacca. The Dutch did the same as the Portuguese in the field of education, allowing Christian missionaries to come to Malacca to establish Christian schools. The British, who took Malacca in 1824, continued the Dutch policy, allowing Christian missionaries to establish schools. While establishing schools, the missionaries spread Christianity to the local population. Residents who embraced the Christian religion would usually send their children to school to learn Christian theology. The fall of Malacca facilitated the British to expand their influence throughout the whole Malay Peninsula. This facilitated the creation of missionary schools established in almost all the states of the Malay Peninsula.

In the early stages of the British colonization of Malaya, the British were not very concerned about local education. They were only interested in trading and mining in Malaya. Many major European companies were brought in to invest in oil palm plantations and tin mining. Having so many investors in Malaya imposed a burden on the British

administration. Because of growing economic ties in the Malay Peninsula, the British needed more administrators to manage investors and the growing plantation workers.

To overcome the difficulties arising from a shortage of administrators, the British established secular schools. The first British school was established in Penang and was called Penang Free School. The British government then established secular schools in capital cities in other states in Malaya. They set up English schools to provide secular education to the children of the cities. The aim was to train them to be administrative officers. Those who had completed high school would be employed in the British government as clerks, administrative assistants, diplomatic officials, and police officers.

In British daily school, whether primary or secondary, children were taught Christian theology so they could become devout religious believers. In addition, the schools aimed to Christianize students who had not yet embraced the faith. Secular subjects such as language, literature, mathematics, and life sciences were also taught to the students to train them to become administrators who were fluent in English and assist the British government in administrative work, such as in the tax department, the department of land surveying, and the judicial and county offices. University education was not emphasized much in society because, in British opinion, it was adequate for the locals to get education up to the secondary level. The British also feared that, if the inhabitants of the Malaya got a university education, they would rise up against their colonization. The British did not intend to produce university intellectuals as this would endanger their political interests in this colony.

Malaysia gained independence in 1957. After gaining independence, the federal government worked very hard to promote educational literacy in the Malay Peninsula. In the postindependence era, there were still many poor people. Many dropped out of school and became illiterate. Due to the high illiteracy rate, the government built many schools, particularly in rural areas so more poor people could get a better

education. Education was free. This provided an opportunity for many residents to at least finish primary school. But the federal government formed in Malaysia in 1963 was not satisfied with this achievement. Many more schools were built so Malaysians could finish at least an SPM certificate, equivalent to O-level in the United Kingdom, which every student must obtain at the age of eighteen years. This was in line with the government's policy of educational democratization.

Education in Malaysia experienced many changes from the time of the Srivijaya and Majapahit. It received the influence of Hindus, Buddhists, Muslims, and Christians and finally the influence of the British government. This influenced the education of Malaysia, which became rich in an aesthetic value system resulting from the combination of religious studies and a secular system. This enriched the Malaysian education system with religious, cultural, secular, and political influences. Although rich with such influences, the education system still has certain problems, which we will discuss in the next chapter.

3

Types of Schools in Malaysia

Malaysia is a multiracial country; it has a variety of different ethnic influences such as Malay, Chinese, Indian, Kadazan, Iban, and native marks. In addition, it has been influenced by different religions such as Hinduism, Buddhism, Islam, and Christianity. As a result of the different religions and cultures, Malaysia has a unique education system.

Portuguese, Dutch, and British colonial establishments also brought great changes to Malaysian education. Colonial interests brought in secular education. The British secular system continues to influence Malaysian education in modern times. Although secular, it contains a spiritual element in line with Malaysia's official religion, Islam, which is developed in accordance with the locals' lifestyle.

In Malaysia, the government manages almost all public schools. Public schools are usually cited as government schools. The private sector also plays a role in the establishment of private schools. This means that schools in Malaysia are divided into two main groups: private schools and public schools. All schools in Malaysia have to follow all the guidelines set by the government. For example, all schools have to use the same syllabi, the same subjects, and the same examinations. Public schools receive full financial support from the government, so students who study in government schools are not charged any fees. Meanwhile, private schools have to deal with their own financial resources. The government does not provide financial assistance to private schools, so

private schools get school fees paid through students and community fund-raising.

International schools from Europe and Australia are granted permission to establish branches in Malaysia. International schools do not use the syllabi issued by the government. Instead, they use their home-country syllabi. International schools do not receive government grants just like private schools. Students have to pay fees to study there. Their own boards of directors usually run these schools. Locals rarely send their children to further their studies in private institutions because of expensive fees. Only the wealthy can afford to send their children to study there. Most students at international schools are the children of foreign professionals who work in Malaysia. International schools use the English language as the medium of instruction. This facilitates foreign professionals' children to study there. Their children may not be able to learn comfortably in government schools where the medium of instruction is the Malay language.

Public schools are also divided into two types, namely national and national-type schools. The difference is that national schools use the national language, Malay, as the language of instruction. National-type schools use the mother tongue, such as Indian and Chinese, as the medium of language. This is the result of the struggle of Chinese and Indian people to maintain vernacular schools during the pre-independence era. These schools were important because they helped the Indian and Chinese students learn their mother tongue to maintain their own cultural identities. Both types of schools receive funding from the government. The difference of instructional medium in the two types of schools provides an opportunity for Malaysians to learn a language other than their parents' own mother tongue.

Other than secular schools, religious schools—namely Islamic school—also play an important role in Malaysian education. Because 60 percent of the Malaysian population is Muslim, Islamic schools are well accepted by the local community. The state government funds this

type of school, and its syllabus is not the same as the syllabi in public or private schools. The instructional medium is the Arabic language. Students have to learn Islamic theology, law, and philosophy. Secular subjects such as science, mathematics, and social science are not emphasized in students' learning, which means the students are trained to be pious religious believers or religious teachers. This differs from conventional schools, which train students to be industrial workers, rather than pious believers. The students who complete their studies in religious schools have to further their education at a university located in the Middle East, such as in Egypt, Iraq, and Iran. They have to continue their studies outside of Malaysia because the government does not recognize the certificate obtained from a religious school. The public and private universities would not accept students from religious schools because the government does not recognize the certificate.

4

The Influence of Politics in Malaysian Education

Education in Malaysia is not free from political influence. The political influence phenomenon has existed since the colonial period when the British began to establish British daily schools. To manage an English school, the British established the state education department in each colonized Malay state. A director, who was British, headed the department. Administrators appointed among the English-educated locals assisted the director. The director had full authority in the administration of all English schools in the Malaya. For example, he had full power in the establishing and closing of schools, the determination of the school curriculum, the appointment of teachers, and the establishment of teacher training colleges. Later, his power was extended, where he gained the authority to deal with the Chinese and Indian school development.

The British brought Chinese and Indian immigrants into Malaya in the nineteenth century to work on large estate plantations and tin mines operated by European companies. At the same time, they also brought in family members to settle down in the Malaya. With the growing population of Chinese and Indians, the demand for learning institutions, mainly vernacular schools, increased in order to enable their children to study. Textbooks from their home countries were brought into the Malaya to be used for teaching and learning in the vernacular schools.

Teachers from the country of origin were also brought in for educating their children.

At first, the British did not intervene with the management of vernacular schools, but with the wide spread of communist influence in the vernacular schools, the British had to intervene in this matter for countering the communism influence. The spread of such influence could jeopardize their political interests in the Malaya. How did the British intervene? The British administration set a new rule. It was mandatory for vernacular schools to register with the state education department if the schools wanted to get government grants or financial assistance. Schools that did not comply with new regulations would have their financial assistance withdrawn or have their permission for school establishment revoked. The registered schools had to comply with the guidelines of the British school syllabus, which was relevant to Malayan society. Any elements associated with mainland China or India were strictly prohibited. Not all these vernacular schools complied with British regulations. Those schools that did not eventually ended up with a lack of funding and were closed.

Through the registration of schools under the state education department, the British more easily monitored the activities of the vernacular schools. Monitoring was important because communist subversive activities were active during the period before the Second World War in the Malaya. The Communist Party took advantage in expanding its influence by using vernacular schools to get political support from the Chinese. The Communist Party sent spying agents disguised as schoolteachers to influence students to support the Communist Party and defeat British colonial occupation. The modus operandi of the Communist Party had long been observed and known by the British. To control the activities of communist subversion, the British government issued instructions to register and regularize the vernacular school syllabus according to the Malaya scenario. The full, tight control of schools by the British weakened the communist effort in spreading

its political influence to Chinese communities. The communists realized that they failed to gain influences using education, so they turned the target to labor unions.

The communist movement reached its peak in Malaysia when communist guerrillas assassinated three European farm managers. Such an incident left British colonists no choice but to declare a state of emergency in Malaya. A curfew was imposed to all Malaya territory, including Sabah and Sarawak. Almost all schools, especially those located in rural areas, were forced to close down. Because rural schools were quite near the forest, a great place for the guerrillas to hide, it became easier for the communists to take advantage of them. The British had to close the schools in order to protect teachers and students from the threat of guerrillas while the British army was warring against rebels. The situation turned critical when rebels forced the teachers and students to join their team using torture. The inhumane acts of communist guerrillas became nightmare for the teaches and students. To solve this problem, the British had to use the Internal Security Act to arrest the culprits who created chaos.

The Malayan insurgency left a devastating effect on Malaya's economy because a large amount of funds was had to be allocated for waging war against communist guerrillas, especially in the purchasing of weapons, recruiting of local militia, and relocating scattering populations near the forest areas. The state of emergency lasted for about twelve years. During the state of emergency, the main economic outputs of the area, such as palm oil plantations, rubber plantations, and tin mining, could not be carried out due to the chaotic internal warring situation. Because there were no economy activities, British revenue input lessened. Most of the financial incomes were used for war, which meant the British colonists had to face an economic deficit dilemma, leaving the British no choice under the administration of Winston Churchill. Local pro-British nationalists proposed a planning of Malayan independence. Because of such serious financial problems arising from war, the British gave

Malaya independence to moderate nationalists for self-governance, and independence was declared on August 31, 1957.

Once independence was declared, the communists had to stop their struggle. They had no more concrete reason for fighting with British colonists. Once the insurgency ended, all the rural schools were allowed to reopen for students' enrollment because the communist guerrillas were no longer a threat for educators and students.

During the pre-independence era, Malayan education was not standardized because of different languages used in schools. There were five types of schools: religious missionary schools, English schools, Malay schools, Chinese schools, and Indian schools. Each school was using its own mother tongue or its own dialects. The students could speak their mother tongue well within their own race. But how would they communicate well with other races if they only had a single language competency? The newly independent Malaya was a multiracial society. This language disparity was a big challenge to the newly formed alliance government that administrated Malaya. So it was decided that there must be a national language that all Malayan citizens had to learn for communication with different races. The moderate nationalists requested that English be used as the medium of instruction, but the extreme Malay and Chinese nationalists wanted their own mother tongue to be used for that purpose. To deal with this pervasive problem, the alliance government and British colonial occupants formed special committees.

In 1950, British colonists established a special committee headed by L. J. Barnes as director to plan a new education policy that suited the Malayan society. Before the planning, he carried out certain research for understanding the Malayan school problem. After the investigation, he proposed constructive suggestions for standardizing the irregularities in Malayan schools. He published a renowned report, the Barnes Report, for the British government's viewing.

According to Barnes's report, the vernacular schools—English schools, Malay schools, Chinese schools, and Indian schools—should be

abolished immediately. Those abolished schools would be replaced with national schools that would only use English or Malay as instruction languages. The national schools would be opened to all ethnicities for furthering their studies. The Barnes Report did not receive a good response from Malayan society, especially Malay society. For them, their language was not emphasized in teaching, thus obstructing their ethnicity. They felt that their children may not understand their lessons well if English were given priority in the instruction. Many Chinese and Indian people felt the same way; they preferred to use their own mother tongues in order to preserve their own cultural survival in Malaya. Without the chance to learn their mother tongue, how could they preserve their own racial culture? They had to deal with that reality.

Following the poorly received Barnes Report, the British colonists organized another committee to investigate the matter again to solve these sensitive issues. United Nations representatives William Fern and Wu Teh Yao headed the committee. In 1951, they were appointed to this committee where they did research about Chinese schools in Malaya. They published the Fenn-Wu Report, where they suggested that the Chinese schools should not be abolished. Their solution stated that it should be compulsory for the Chinese schools to learn three languages— Malay, Chinese, and English—in order to adopt them into the national education system.

But such a solution received a negative response from extreme nationalists. It offended them because they were afraid such a solution would deteriorate their political interests in Malaya.

The British colonists found that it was an extreme challenge to fulfill the educational needs of different ethnic groups in Malaysia. A special committee, the central advisor committee, was formed in 1951 to do more research following the previous two reports. This committee consisted of twelve members from various races and British officers. This committee held an intense debate, finally agreeing with the suggestions in both of the previous reports. The debate's conclusion was that the mother

tongue would be used as an instruction medium in vernacular schools and English would be used as a national language. One more special committee was established in 1952 to study the three previous reports. Finally, representatives from all races and British colonists settled the problem through a compromising method. The report was brought to the British government and approved as the Malayan Education Ordinance of 1952. This ordinance would be used as a legal method to protect the educational interests of various races. Any decision made by the government had to abide by this ordinance in educational development.

Two years before Malaya independence in 1955, the British colonists held a special general election to pave the way for self-governance. The alliance party gained the most seats in the election, making it the biggest party to administrate Malaya after independence. Once the new cabinet was formed, Tun Abdul Razak was appointed as education minister in 1956. He formed one more special committee to plan new education policies that suited Malayan society. In the end, a special report, the Razak Report, was published.

In this report, he suggested that more national schools should be established where the Malay language would be used as an instruction medium as well as the national language. It was compulsory for other vernacular schools to teach Malay language. Finally, the Razak Report would be used as a guideline in the implementation of education policy in Malaya. According to this report, the students in Malay schools should be competent in two languages, Malay and English, whereas the students in other vernacular schools would be competent in three languages, Malay, English, and Chinese or Tamil. It was compulsory for all students to get a pass in the subject of Malay language if they wanted to get a complete exam certificate.

In the policy implementation, we can notice that the politicians emphasized the Malay language rather than English to fulfill their political interests. Even though this language was not strong enough in supporting intellectual activity such as transferring modern civilization

knowledge, the international community prefers English more. For him, using English was an act of overworshipping the colonial mind-set. Such ridiculous thinking surely would deteriorate the students' competency in the international arena.

During the postindependence era, the problem of poverty, especially the natives who lived in the rural areas, became a main concern to the newly formed alliance government. The villages located in rural areas had one main critical social issue, lack of schools for education. Also, rural students had to pay the expensive school fees. The poverty was a sensitive issue during that era.

Realizing the education needed from rural folks, the alliance government formed one more new committee for investigating the matter, which Abdul Rahman Talib, the education minister during that time, headed. He reviewed the Razak Report. The report had been studied in detail, and some new suggestions were added on to improve it. Talib suggested that the educational opportunity should be free for all Malayan students to solve the poverty problem. Also, it was a way of improving their social status. The Malaya needed more educated labor in boosting economic activities, especially commerce and industries. Second, the moral studies or religious studies should be more emphasized on education. These two subjects would be used to inculcate ethical values to students, training them to become responsible citizens to this young nation. The civic education was abolished and replaced by two previous subjects. In his point of view, civic education was irrelevant to young nations such as Malaya compared with developed nations such as the United States. For the author, civic education should be more emphasized, same as moral or religious studies because Malaysia was a democratic civil society.

The alliance government had drafted a new act, the Malayan Education Act of 1961, by using a combination of the Razak Report and Talib Report as references. The Malayan Parliament approved it as a legal approach and used it as a guideline to deal with Malayan education

development. This act consisted of rules and regulations that had to be abided in implementation of education policy. The interest of every ethnic education had to be protected using the Malayan Education Act of 1961. Thus, this act had solved the sensitive racial issues arising in Malayan education.

According to this act, the suggestions in the Razak Report and Talib Report had to be executed in every public school, which meant that all public schools were compulsory in using the same syllabus, teaching subjects, exam system, management system, and instruction medium for producing a standardized education to all Malayan students. The schools that were not complying with the regulations suggested would be fined or have their license permits withdrawn.

The Malayan Education Act 1961 worked well in education development, where all of those who dealt with education had to use it as the ultimate guideline. The alliance government missed one more matter, the irregularities and outdated academic syllabus used by all Malayan schools. Although all the schools were using almost the same syllabus, the academic levels were different. Some of the schools might use a moderate syllabus, but some of the schools might use a tougher syllabus, which was an unfair scenario to all Malayan students. Also, the old syllabus was more academic, emphasizing teaching rather than cocurricular activities.

In the ministry's point of view, it was an unhealthy phenomenon to all students. Other than excelling in academics, the students must also be active in sports to ensure a healthy body that helped them to do well in studies. It was believed that doing well in both academics and sports would help to produce a well-rounded Malayan citizen. Besides, the old syllabus was outdated already. It only suited an agrarian society. It too strongly emphasized theoretical teaching rather than practical learning. Such a syllabus was no more suitable for use in Malaya for helping it achieve industrial-nation status.

To improve such situations, the alliance government established one more new committee, the cabinet committee headed by Dr. Mahathir,

who was education minister during that time. This committee was responsible for reforming the irregularities in the syllabus used by Malaysian schools. A new department, the curriculum development center, was established under the education ministry. This committee proposed that a new type of syllabus, Integrated Curriculum of School, would be developed for all Malaysian schools. This curriculum consisted of all aspects of Malayan society, especially in religions, cultures, customs, races, sports, local lifestyles, and political aspects. It helped to cultivate racial harmony values among Malayan citizens.

Other than curriculum skills, the basic academic skills such as reading, writing, and calculations were also mainly concerned in the curriculum implementation. Lastly, the outdoor activity such as sports was also taking serious consideration in the personal student development. As we can see, the cabinet committee was trying its best to plan for a standard education system that could fulfill the Malayan society requirement from all walks of life. Hence, the education minister published the Cabinet Committee Report, in 1979, which continues to be used as the guidelines in Malaysian education.

The Negative Effects of Political Influences

In Malaysia, the education system is biased and polluted with political motive, where it is used to brainwash society, especially the innocent students, starting from elementary level to university level. From primary one, the young students are educated on the importance of loyalty to king and country, which is important. It is good to have a spirit of patriotism for our country, where we are born, live, and serve. But the problem is that the students are taught loyalty more to certain political parties rather than to king and country. This causes intense controversial debate among politicians. Some agree; some do not. Whether the society likes it or not, some politicians do not care. They are exploiting the

concept of loyalty to king and country to brainwash the students about loyalty to certain political parties.

In the brainwashing process, the students are taught that, if they are not doing as instructed, such as supporting only one political party, they are enemies of the states who commit treason to country. Those preaching indirectly act as political propaganda for strengthening the power or position of certain political parties in Malaysian society. Such elements could be found in the social science subjects in Malaysian schools. Other than academic subjects, certain campaigns are launched in schools to spread the sphere of political influences such as "Malaysia can," "Long live our language," and "Vision 20/20." These acts of political indoctrination train the students about the importance of loyalty to certain political parties. The situation turns worse when Malaysian students lack critical thinking. They blindly believe what a politician is talking about. Even though sometimes the politicians make wrong decisions in policy implementation, those students remain silent, thinking that only the politicians would make the best decisions for all of them. The incorrectness of policy implementation angers the professionals such as doctors, engineers, scientists, and lawyers. The professionals voice certain constructive opinions, expecting to improve the distressing situation, but to no avail. The society itself is not interested in listening. How ignorant they are. The indoctrination does control society's mind-set. This is how Malaysians think. They seldom have their own opinions, leaving it for politicians to decide.

Also in the indoctrination process, students are taught the importance of supporting leader from certain political parties. According to the preaching, only certain political leaders would bring hope and vision to society. Things get worse when religion is used in political indoctrination. Religion is exploited in preaching, where it is a sin for a person to support certain political parties. Such political leaders are portrayed as representatives from God, which means they are granted certain powers to command mankind. Any student who questions his or her political

authority would be classified as heretical. He or she may be subjected to instant school suspension due to this radical act. Hence, the authority of a political leader in Malaysian society cannot be questioned or challenged, a big offense in law. Due to this belief, local media always portray the political leaders as national pride, wherein it is an honor for all Malaysian society to support him or her. The citizens who support them would be granted higher positions in political parties or government-owned enterprises. Inside the Malaysian textbooks, the politicians' backgrounds would be fully described. The purpose is to indoctrinate the students about the politicians' contributions to the country. They are always asked to write essays and reports and draw posters to praise the contribution of politicians, a responsibility for all Malaysians to feel proud of their contributions. The politicians have also launched certain mega projects before, such as PETRONAS Twin Tower, Cyberjaya, and Putra Jaya. The students are asked to write essays praising the politicians' contributions in creating such gigantic projects for the benefits of Malaysian citizens. In reality, the projects only benefit government-owned enterprises rather than casual civilians.

One of the greatest insults in Malaysian education is that those who are in power use this human capital development tool to attack political opponents, especially those who are from opposition parties. Starting in primary one, the students are taught how dangerous the opposition party is to this country. The party that is controlling the government portrays the education system as the person who is very loyal to the country, willing to serve Malaysian citizens with sincerity. The party that is not in government, such as the opposition party, is portrayed as national traitors. They are labeled or condemned as culprits who bring chaos to society if they issue any different opinions. This means that the political party that supports government would be acting as a public opinion maker only. If the opposition party issues any different opinions, the party in power would condemn them as rebels trying to start an uprising in the government. Also, they would be classified as culprits who are committing treason.

How could such irrational thinking exist in Malaysian society, which is a civil society? Let the reader judge it rationally. In Malaysian schools, students are taught not to involve themselves in any civil strike or street demonstration. Involvement in street demonstration is outlawed. But according to the federal constitution, citizens have their right to assemble and express their views peacefully on the street, one of the universal declarations of human rights by the United Nations. There was a school regulation that stated if students supported opposition parties, it may lead to immediate school suspension. This rule was withdrawn after many parents complained.

How about education policymaking? It is quite undemocratic in its implementation. The policy is planned usually without the knowledge of society and professionals. Those who are involved in policymaking are politicians and government officials. How could those fellows produce quality education policy that suits the needs of Malaysian society? Policymaking should involve all walks of life through a compromising process. Education experts such as professors and intellectuals should be asked for this purpose.

This policymaking process is not transparent enough for society. Hence, the education system formed its stereotype, which means all Malaysian students are forced to accept the same type of education without considering their personal intellectual levels. That is the big issue here. It is no different with education in communist countries such as Cuba and North Korea, where their citizens are educated to blindly follow their leaders' needs. For the author, it is a tragic disaster to Malaysian society. All schools have to obey the regulations from politics. If not, the threat of instant license withdrawal would be imposing to them. Other than nontransparent policymaking, the cronyism in education remains a big issue in Malaysian society, where corporations that have good relationships with politicians are given a chance in project tender, especially in school building construction and providing textbooks and Information and communication technology equipment

in schools. Those companies are responsible for educational development in Malaysia. They are the cronies that conspire with politicians in corruption, where some financial allocation have been kept secretly in their personal accounts. Not all the fund allocation goes to education development; some of it has gone into the politicians' pockets.

Because politics influence Malaysian education, its neutrality is disputed. It is hard to produce great thinkers or intellectuals because the education itself does not encourage the students to have critical thinking. They are asked to follow blindly what they have been taught according to the syllabus without considering whether it is outdated or not. Those students who have their own opinions would be classified as idiots. The same matter applies to the educators. The educators have to blindly follow the syllabus prepared by the government without considering the intelligence level of a student. Because almost all educators are civil servants, they have no choice. Like it or not, they have to obey the politicians' instruction. Those who are not following orders, including principals and education directors, would be subjected to immediate suspension. They also have to obey the instruction like other educators. Usually, those with higher positions in education own political backgrounds such as memberships in certain political parties. By using such political background influence, it helps some educators get promoted to higher positions in education such as principal or director. Could the reader notice how strong the political influence in Malaysian education is?

Social Effects

The political intervention in Malaysian education also created some social effects, especially in nation building and multiracial integration. Political manipulation arises because of inaccurate historical teaching in Malaysian public schools, using the same approach as in Japanese

schools where the Pearl Harbor incident is considered national pride. In history taught in Malaysian public schools, the Malacca sultanate is considered an origin of the country named Malaysia. For the author, this is inaccurate. Before the existence of the Malacca sultanate, the ancient Kedah sultanate, which is located at Northern Malay Peninsula, recorded in Merong Maha Wangsa Annals, existed before the arrival of Parameswara from Palembang, Indonesia. Some of the older kingdoms such as Pattani, located in the southern part of Thailand, did exist earlier than Malacca sultanate.

Such lessons create great confusion among Malaysian students. It also creates intense debate among extreme politicians. Some fanatics use the Malacca sultanate as a historical fact to strengthen their political influences in Malaysian society, claiming that their forefathers were the ones who contributed the most in this free land. But the reality is that, other than their forefathers, the forefathers from other ethnicities also contributed a lot to nation building. We cannot just mention our contribution to country and ignore the others' contributions. For the author, such thinking is not open-minded and is ungenerous when dealing with others.

Other than historical subjects, religious lessons and moral education in public schools are also considered controversial subjects that have to be faced by Malaysian students. Religious studies especially have been used to brainwash students. They are taught to be pious religious believers, which can train them to become disciplined citizens. But the problem lies in the syllabus itself. It contains certain elements that create hatred toward other religions by condemning other religions as the devil. Such preaching causes interreligion disharmony because religious followers become suspicious to other religions. This suspicious thinking can provoke the interaction between different religions, and it may cause racial conflict in the future.

How about moral education? This subject emphasizes the importance of moral values as a responsible citizen. The students are trained to

practice moral values in daily life when dealing with society. But the problem arises because the moral values they have learned are only focusing on one religion. It is the problem of a lack of universality. As a society endowed with multiple ethnicities and religions, at least the moral values learned should gain a mutual agreement from all religions. The moral values emphasized in one religion may not be accepted by others. That is at issue here. Students from different religions are forced to adopt moral values from a single religion only, which is not suitable in a multireligion society. The representatives from every religion should hold a dialogue to discuss the most suitable moral values that should be taught to Malaysian students who come from different religious backgrounds.

The language or medium of instruction in Malaysian schools sometimes becomes a sensitive issue when some of the racial extremists politicize it. Those extremists claim that the vernacular schools could create racial disunity in Malaysian society. They voice that all Malaysian schools are compulsory, using national language only as an instruction medium. According to them, it is the only way to create racial harmony in society.

What those political extremists say does not make any sense. The existence of vernacular schools has provided opportunities for Malaysians to learn their mother tongue. So has national schools. It has provided Malaysians opportunities to learn the national language. The existence of national and vernacular schools has provided more opportunities for all Malaysians to master the languages and understand the cultures from different ethnicities in a more detailed manner. For the author, this is a very unique scenario, which is seldom to be found in other countries. So the variety of culture and beliefs arising from this unique scenario makes Malaysians richer and creates a special society to be proud of in today's modern world. Almost all Malaysians have enjoyed living in a multiracial and multireligion country, where they do their daily chores peacefully and also celebrate festive seasons excitedly. But some political extremists are jealous of it. From time to time, they politicize the

language issues in education, hoping to create hatred among different ethnicities. The language issues in education have been politicized in almost every Malaysian general election. By using such modus operandi, those politicians believe their supporters would increase. Those who are ignorant would be cheated for sure. I can conclude that those politicians are almost the same as the KKK in US history, where this organization would victimize the Negro to achieve their political goals.

The language issue is related to human rights issues as well because it is a basic human right that should be owned by every race in using their mother tongue for daily communication. Other than language, the freedom of being involved in any social association remains a sensitive issue in Malaysian education. For example, it is illegal for a Malaysian student to join any political party and also be involved in street demonstrations, which the universal declaration of human rights guarantees. According to this declaration, any citizen is free to join peaceful assemblies and also involve himself or herself in any political party or legal social association. This declaration is a little bit of a contradiction in Malaysian society, where the public school students are prohibited from joining any political parties or street demonstrations. Isn't this an insult to their intelligence? The high school students are mature enough to make their decisions. Why are they not allowed to join in with politics? The politicians think the students are still immature in political affairs. It is not necessary for them to take part in it. For the author, this is an immature statement. The high school students who are eighteen years old should be considered adults already. They should be given a chance to take part in politics because they are part of society. If they can cast a vote in general elections already, why are they not allowed to be involved in politics? By taking part in politics, they could provide newer ideas to government to help to create a more progressive society. Isn't it a good idea to let them take part in politics? The older generation should be tutoring them, teaching them to become mature leaders for achieving a better tomorrow.

Finally, the biggest issue that is almost forgotten by Malaysian society is the recruiting of triad society, or gangsters, by certain politicians. Some politicians recruit those culprits for fighting against their political opponents by using sabotage approaches such as assassination, vandalizing opponents' property, and sexual harassment. Those culprits would be paid to do the sabotage job. The police could not do anything because of lack of evidence in prosecution. Those culprits are the undisciplined students whose schools suspend them because of "discipline problems." By taking such advantage, some politicians are willing to secretly recruit them as underground followers. The culprits would be loyal to certain politicians once they are paid a great amount of money.

Could you imagine how hypocritical those politicians are? In one aspect, they are busy dealing with policy implementation, but in the other aspect, they are recruiting the triads for protecting their political interests. It is really an ultimate nightmare for Malaysian society.

5

Governmental Policy in Education: Is It Improving the National Education System?

Since Malaysia achieved independence from British colonists, the newly established Malaya Federation has paid great attention to national education development, realizing the importance of education in nation building to boost up its economic performance and unite all ethnicities under one roof. British colonists encouraged the planning of a new education policy that was suitable for Malaysian society since the postindependence era. British colonists most welcomed an education system that brought racial unity, as it was a prerequisite for Malaya independence. In the implementation of a new education policy, the World Bank provided some financial loans for Malaysian education development as a technical support, whereas the ministry gave policy consultant support for such development. The power of supervising and monitoring lay in the hands of the ministry where its burden was quite heavy to make sure all policies launched were executed properly. Some new education policies such as "Standard curriculum of schools," "Malay language as medium instruction," and "democratization of education" were launched to improve the education standard. The purpose was to get rid of the problems of school dropouts, especially the students living in rural or countryside areas. This was due to lack of attention paid by

British colonists in the education sector, especially for those living in the countryside area.

First, we will look at how the education democratization policy was implemented in the pre-independence era. For fulfilling the need for education among Malaya civilians, a lot of public schools rather than private schools were established to provide education opportunities for them. The poor or rural residents had no more worries about access to education. They had the same opportunities as city folks to receive formal education other than traditional education from their forefathers. Those who received formal education could have more opportunities to upgrade their social status from farmers and fishermen to professionals. Education is important in social status mobility, and it does happen after fifty years of achieving independence from British colonists. So the public schools have provided education equalities for all Malaysians in improving their social status other than standard of living. Besides, tertiary education is also given priority in this aspect. The public universities, such as Malaya University, were constructed to provide cheaper tertiary education for the poor. Those studying overseas would be granted scholarships for furthering their studies.

During British colonization, the establishment of English schools was given priority, especially in urban areas. The English language was used as a medium of instruction for teaching and learning. Such language makes it hard for the locals, especially the natives, to study well in English schools. They found it hard to learn properly in school; hence, they would drop out. Most of them did not understand the language well, except those who worked for the British government. The language problem caused the natives' parents to be uninterested in sending their children to study at an English school. The parents themselves also could not understand English well. Fearing colonization, the natives preferred to teach their children life skills or religious knowledge inherited from their forefathers.

After independence, the new government decided to solve such an irritating problem. By changing the instruction medium from English to

Malay, it was believed that the natives could learn well in public schools. In the implementation process, it was compulsory to teach all school subjects in the Malay language. Students had to learn, write, and speak in Malay, and teachers were required to conduct their teaching in Malay language also. Other than academic subjects, administration matters in school also needed to be written in the Malay language, especially official documentation and ceremonies in public schools, to make it easy for natives in academics. Such a move encouraged more native parents to send their children to public schools.

In order to standardize the benchmark of national education, the ministry implemented a new syllabus for all public schools, knowing that all vernacular schools in Malaysia were using a different syllabus based on their own ethnic cultures. A latest one, "integrated school curriculum," was launched to be used by all public schools in Malaysia. This syllabus was important to Malaysian society because it consisted of elements that were important in nation building and inculcated racial unity. The previous vernacular syllabus was abolished and replaced with the latest syllabus. This curriculum suited Malaysian society because it consisted of education of mutual understanding between students from different ethnicities and religious backgrounds. Under this syllabus, the students were taught to respect the others who embraced different religions, which meant great emphasis to mutual understanding for ethnical customs was placed on learning. In addition, the reading, writing, and arithmetic skills were given great emphasis in its implementation too, knowing that most rural students were very weak in those skills. The previous three skills were very important in helping them improve their life quality.

Knowing the importance of scientific knowledge for achieving industrialized nation status, the ministry launched another significant education policy, that is, science and mathematics taught in the English language, where previously, both of the subjects were taught in the Malay language. The government realized that English was very important for transferring scientific knowledge, especially in engineering and

the medical field. This language is widely used in both of the fields at the international level. An industrialized nation surely needs a lot of science-stream students who have mastered both engineering and medical knowledge, which means a nation should pay more attention to human capital development in scientific knowledge. Under this policy, the ministry instructed that both science and mathematics were to be compulsorily taught in English. In addition, Malaysian students were encouraged to take science stream as their choice of education when they were furthering their high school studies.

What the government did was very ambitious in developing industrial sectors. The government wanted more laborers who were scientifically skillful in fulfilling the drastic demand from the industrial sector in propelling Malaysia as a great industrial nation, such as the United Kingdom, the United States, and Japan. So the students who furthered their studies in medicine or engineering would be given priority, especially in scholarship application. It was also a learning opportunity in public higher education in Malaysia.

Due to the implementation of those policies, it did give some improvement in Malaysian education, especially in the literacy aspect. During the postindependence era, UNESCO published an official report about Malaysian literacy. It was about 40 percent or less. Nowadays, its citizens' literacy has increased to about 80 percent or more. Can you imagine how significant this increment is? Although its literacy rate is not as good as Cuba, which stands at 100 percent, Malaysia still can be considered an educated country among the third-world countries. Its literacy rate increased about 100 percent within fifty-six years of independence from the British. Malaysian society seldom dealt with problems of people who cannot read, write, or calculate in their lives, which means almost all Malaysians have mastered three of such skills. Besides, almost all Malaysians own at least a level of the Malaysian Education Certificate (SPM), which is equivalent to the O-level in the United Kingdom. The higher literacy rates in Malaysia attracted a lot of

foreign investors to invest in this wonderful land. In the investors' point of view, a society with education can operate their plants properly. Surely, the industrial profits increased and boosted the local economy.

The education policy looks wonderful theoretically, but some problems arise from ineffectiveness of implementation, especially undemocratic decision making. The ministry implements it using a "one sizes fit all" concept without researching the school learning environment in detail. The policy did succeed at some public schools but not all. It works at schools with smaller student populations. However, it does not work well in schools that are dense with large student populations. In this scenario, such a only works in certain schools. The ministry assumes that all public schools can use the same policy without considering the real scenario. How inconsiderate, isn't it? There are critics in society, but the ministry pays no attention to them. So, no wonder there are some Malaysians who cannot read, write, speak, and calculate properly even though they receive twelve years of education in public schools. Society might blame the educators for not doing their job properly. But the problem is how can the educators can give special attention to each student if the class size is very crowded with fifty students in populated public schools. I think the ministry should deploy more teachers in populated public schools to make sure the policies work according to the plan or maybe construct more schools to make the overpopulated schools less populated. If this problem is not solved, this scenario could turn worse because the Malaysian population increases annually. Finally, without instant remedies from the ministry, the education policy could face failure in its implementation.

One of the most ineffective policies implemented by the ministry is the "science and mathematics in English" policy, where educators are forced to use English as medium of instruction. They have no problem using English for teaching, but the problem lies in the students themselves, especially the natives. The natives are not fluent in English. Most live in rural areas where they lack English reading material,

compared with urban areas where their citizens are fluent in English. The urban students have no problem with English. How about the rural students? They are not good in this language. It is a nightmare for them to learn science and mathematics during teaching sessions in the classroom. They can't understand what the teacher is teaching in the classroom. Sometimes, the science and math teachers have no choice. They have to use their mother tongue, Malay language, to teach to make sure the students understand the lesson. They cannot improve their students' English proficiency, and it leads to deterioration of scientific understanding.

The Malaysian society accepts the policy implementation at the moment of launching, believing the government would improve national education according to international standards. For them, it is good news. The government itself also shows dedicated effort in the implementation process where a great deal of financial budget is granted for it. The great budget, following the loan from the World Bank, could make the policy run more smoothly. Other than budget, the government also launches some campaigns to create awareness about the importance of such a policy using conventional media. The purpose is to educate the public on how important the policies are. At first, the Malaysian citizens accept it well without any objection. Gradually, certain Malaysian citizens feel irritated by such policies, causing some unpredicted problems to arise from it. For example, some children still cannot read, write, and calculate properly even though they receive six years of primary education. Some parents have to send their children for tuition in order to improve their children's academic skills. Other than previous skills, their children also experience bullying threats from a triad society in school due to uncontrolled students until the police are forced to intervene in such "social criminals." How ignorant those culprits are.

The medium of instruction used in teaching also offends parents, especially "Science and Math in English." Their children cannot understand the science lesson in school. It does not boost their English

proficiency, and their mother tongue deteriorates. Finally, the students cannot speak English or their mother tongue properly. How embarrassing such a scenario is to them.

Although many issues arise from the ineffectiveness of the execution of education policy, the government itself remains silent. The conventional media always reports the education issues monthly. The government promises to solve them, but not much action is taken to deal with the issues. Finally, the public and educators are blamed as troublemakers who blindly create issues. Can you just imagine that, when a problem arises, blaming the others is a great solution for it? Finally, the government decides to solve it if it has received complaints for many years. They try to solve it, but it is too late. The problems turn critical and cannot be solved within a few years. An extra budget has to be allocated to revise, review, and reconstruct the troubled policies. To solve the problem, the government replaces the previous policies with the new education policy known as the "National Education Development Plan," which ends in 2020. The new policy aims to solve the Malaysian education problem. If you properly read the plan, it has nothing different than previous policies. What is different is the graphic design at the whole set of the national education development report.

6

Geographical Terrain Obstacles: Incomplete Facilities in Rural Schools

The government has built many schools across the country to facilitate Malaysians to get easy access to education. Before Malaysia gained independence, most public schools were predominantly built in urban areas. Religious schools could only be found in the villages. For those who wished to further their study in a public school, they had to migrate to the city. They had to stay in a hostel while studying in the city. Public schools were places that guaranteed their future—that is, students may have had the opportunity to enter the university with an exam certificate from a public school. This was contrary to those who wanted to learn in religious schools. School certificates were not recognized, and they had to further their education in the Middle East. These were some of the barriers that Malaysian students faced in the British colonial era.

After independence, the federal government strived to overcome this problem, knowing the importance of education to national development. The government extended the construction of schools in rural areas to provide educational opportunities for rural students. Students did not need to migrate to the city to look for educational opportunities. The primary schools were built in almost all the villages in the Malaya Federation, while many secondary schools were also built in the village areas. This scenario facilitated village students to further their studies

without the need to migrate to the city. They could get the same academic certificates as urban students.

However, Malaysian students, especially in the rural areas, were still interested in studying in the city. Perhaps the reader thinks it is due to the accommodating facilities provided. Although the accommodations became the main concern, there was another reason, which was city life itself. Urban life promised a better quality of life due to more complete public facilities. Public facilities such as Light Rail Transit, buses, phones, Internet access, libraries, and recreation centers promised a comfortable life for the metropolitan citizens even though city folks sometimes had to face traffic congestion. Other than the public facilities' convenience, urban areas also promised opportunities for self-development such as employment and business opportunities, along with opportunities to explore a wide variety of educational institutions.

One of the most significant differences between urban and rural schools is that urban schools have more complete facilities such as computers, Internet, broadband, and libraries. Reference of knowledge is more easily carried out in urban schools. Urban areas are more complete with road access. This makes it easier for buses, LRTs, and automobiles, in a relatively small distance compared with their friends in the village. After all, homes are quite close to the schools. Students usually go to school via school bus or parents' fetching. Travel time taken usually does not exceed one hour. The longest we have is a half hour.

The reader may wonder why some students from rural areas are still interested to further their studies in cities even though the government has provided rural schools. What's the problem here? Indeed, the government is providing a school, but several reasons annoyed rural students. The reason is there are terrain obstacles such as mountainous rural areas in Malaysia, especially Sarawak schools. In Sabah and Sarawak, we can find mountains, forests, and rivers in rural areas. Such natural obstacles could trouble the journey to schools. There are aboriginal villages in the mountains. Some are in the dense forest; some are in

the upper reaches of the river. The distances between the indigenous settlements and schools in the towns are pretty far, probably about more than fifty kilometers. There are students who are forced to walk to school because there are no roads to their villages. Some are forced to use a boat as it is the only option to get to school. Consequently, some students stay at home while their brothers in town learn. Students who depend on the river have to take the boat for about two hours to get to school because the distance is too far otherwise. Buses, cars, and buses cannot be applied in this area.

Not only do natural barriers complicate the process of constructing schools, they also create troublesome scenarios to students learning in school. Just imagine there are students who have to walk for two hours, across forests and rivers, and up and down hills to go to school in the small town nearby. No schools are built in the indigenous settlements as they are too far from urban areas. The government is not interested in building a school there because the area is too removed and it is difficult for delivery of construction materials.

Because of terrain obstacles, the government is not very keen to build roads and highways into rural areas because it involves high costs and the terrain is mountainous. Also, many rivers and wetlands limit road construction. Rural residents are forced to use traditional methods, such as boats, to travel from home to school. Traditional boating methods are confronted with the threat of water currents. Similarly, rural students have to contend with the threat of torrential streams that might claim their lives at any time. How about thick forests with no rivers? What they do is walk across forest trails through the woods. School buses or cars do not apply here because there are no roads in the forest. Forest covering the mountain areas creates difficult journeys. They have to go up and down the mountain. Their journey to their destination is quite time-consuming.

Lack of transportation in rural areas has led to the problem of lacking the basic facilities such as school buildings, chairs, desks, and computers.

We know there are certain remote areas that are not directly accessed by road. Main transportation access to that area is by boat. The absence of roads complicates the delivery of construction materials because the material delivery process requires large trucks. Similarly, tables, chairs, computers, and ICT tools are indispensable to the learning process. This deficiency causes the material transportation to be especially time-consuming. Indeed, a boat can carry light items such as furniture and ICT. How about bricks and cement for the school construction? This situation is troublesome for building local schools. They are forced to use natural materials to construct schools, such as wood in the forest, including tables and chairs used. A school has to be built using local raw materials. How about the ICT tool? It is experiencing disadvantages compared to urban schools. The government provides a laptop computer. But rural schools face other problems, such as insufficiency of telephone lines, fiber-optic cables, and broadband required for accessing the Internet.

Another problem arising from the geographical barrier is the lack of water and electricity in rural schools. To overcome the problem of lack of electricity, a machine like a small electrical generator provides electricity for using fans, lights, and computers in the schools. A small power generator is not sufficient to meet the requirements of the electricity consumption in schools due to student population growing every year. Diesel-powered machines sometimes suffer from damage caused by excessive usage of electrical currents. When a machine breaks down, the school has to use candles for the dark, cloudy weather. The school can call a technician to repair it, but it takes time for a technician to arrive due to the distance between the school and the town center. In addition, the technician has to use the river as a transport to school.

The water is also a problem plaguing rural schools. There is no potable water in the pipes supplied to the school because of the terrain obstacles like mountains. Typically, the school will use water from the river for daily living such as washing and bathing in the school. People

who do not use tap water might deal with problems of contagious diseases—for example, chlorella. How about a school that has no river? It is certainly difficult for them to get water. That is why most rural schools are built near rivers due to the difficulty of otherwise getting a water supply.

7

Inefficient Management and Administration of Schools

Management is very essential to an organization, whether it is a government agency or private company. Good management enables an organization to run smoothly and become more productive. It facilitates efficient management of the administration and the subordinates to do their jobs comfortably. This atmosphere can avoid conflict or office politics. The moral of the lesson is that the employer and employee are free to carry out their own duties without interfering with each other's duties. This is the most basic management concept that any organization should know. However, the basic concept is not fully appreciated in Malaysian public service, particularly in the management of public schools, because public schools in Malaysia are too confined by the government's political influence, meaning that the government has full authority over the public school until the school itself loses authority in school administration. The administration has difficulty making their own decisions unless they receive further instructions from the ministry or education department. Like it or not, an administrator must conform to the government's policy and implement it immediately.

Public schools in Malaysia are facing a unique phenomenon—that is, bureaucratic administration. All decisions made by the school need to get approval on many levels from the principals, the education department to the ministry. This process actually takes quite a long time because each

level requires filling out forms and submitting reports for viewing by the officers involved—for example, planning official ceremonies, sports and extracurricular activities, and public examinations. The approval process is time-consuming. This situation tires teachers or officials involved. A lot of time, energy, and money are wasted just to get approval for a casual activity at school. Isn't it an irrational act?

Actually, these hurdles have to be reduced to makes it easier for an officer or teacher in charge. Their burden is heavy because they have to contend with many students and parents. The large number of people will certainly complicate the implementation of activities in school if this bureaucracy is required for the activity's approval. Not only application for activity approval, school admission processes and school exchange also involve the same process. Parents involved feel uncomfortable with such annoying bureaucratic procedures.

Bureaucracy is worsened by a "little Napoleon" culture that exists in schools, the department of education, and the ministry. What is a "little Napoleon"? We know that Napoleon Bonaparte was an autocratic military commander who refused to listen to his followers' advice. He wanted all followers to blindly follow orders. At first, he won in a series of wars. But the United Kingdom finally defeated him and sent him into exile. We should learn from this history—that is, we should not become autocratic leaders.

But history has repeated itself in Malaysian education, ranging from the education minister to the school principal. The minister himself acts as a "little Napoleon." He wants all education officials, principals, and teachers to blindly follow his education policy. Anyone who does not follow orders will be subject to disciplinary action. Some policies that deteriorate the standard of education were launched—for example, science and mathematics in English, school-based assessment, and ICT in education, although it got resistance from the teachers and parents. Finally, this project failed, resulting in billions of wasted money. Money wasted could have actually been used to build more schools and recruit

more teachers. Wouldn't that be nicer? In the implementation of the policy, a lot of money was wasted in printing new textbooks, providing paper supply, and purchasing laptops. All this action consumes a lump sum of expenditure.

Because of "little Napoleon" culture as practiced by the ministry, a heavy workload burdens the principal. The ministry always directs the principal to improve the quality of the school. School quality is relative to the financial provisions from the ministry. Just imagine how the principal improves school quality if the financial provisions were insufficient. For example, the principal is asked to organize the event and the campaign that might or might not improve the quality of the school. At the same time, the financial allocation is not sufficient to organize the event. Isn't that a great pressure on the schools, in particular, the principal? To plan a campaign, such as the Love Our Language campaign, principals are often called for meetings in the education department. Most of the time was spent for meetings, and the principal did not have time to monitor teaching in schools. The responsibility of monitoring switches to the deputy principal, who has to be burdened with work because he or she had to conduct the monitoring while the principal himself or herself was busy with meetings in the education department. This scenario makes the management of the school become less effective due to the lack of monitoring from the principals. When education officials pay a visit to school, they blame principals for not doing their job. But in reality, the problem arises from the attitude of the "little Napoleon" as practiced by the department.

We know that the principal has to deal with an "autocratic politician." The teachers at the school are also burdened with the workload due to the behavior of the "little Napoleon," particularly administrative work that involves managing files. Many files attached to the report have to be provided to show that the teachers are doing their duties. Actually, the teacher's duty is to teach, but teachers are asked to do something that is not relevant to the job. Indirectly, the teacher works as

a clerk. Too much time is spent on documentation files. Thus, teaching and homework marking is neglected. If teachers' lack of focus in teaching is due to the file documentation, how could teachers deliver their lessons effectively? Of course not. The purpose of file documentation is to fulfill the ISO standard, but rather, it interferes with the teaching. Finally, the victims are the students themselves. Students have to learn on their own, looking at the teacher managing the file in the classroom. Can this ISO file preparation improve students' academic achievement? That's the question mark here. Files provided will be kept in a confidential room. It is classified as confidential files. In the process of producing the files, a lot of time is wasted. A large amount of money had to be spent to purchase the files and papers for that purpose. Actually, what teachers need to do is just enter the information in the database only. Considering the present era is the age of ICT, the use of ICT will reduce such annoying procedures and save paper. If the department needs a report instantly, they can access it using the Internet.

Due to the inefficiency of the school's management, the community is not willing to cooperate with the school to ensure academic excellence for their children. Parents are less optimistic about the school's efforts to educate their children in the process. Instead, they send their children to extra classes at private tuition centers outside school even if they have to pay more. At the tuition center, the teacher there will guide the students fully in learning because he or she does not have to deal with the paperwork burden as found in public schools. There are parents who send their children to private schools to get a better education. The same as the tuition center, teachers in private schools have less paperwork to manage. More time is used to teach and guide them in achieving better examination results. After all, most modern parents are busy working. They do not have the time to come and talk to the school about their children's achievements. The cooperation between teachers, schools, and parents becomes less and less due to time spent working in the office.

8

ICT Implementation in School: The Biggest Failure

The twenty-first century is the era of information technology, as a legacy of the twentieth-century electronic circuit development. Since the seventies, in the twentieth century, Internet technology had become an essential tool of human civilization for accessing the latest information. Through ICT, the latest information can be shared quickly to all corners of the world. Historically, the American military invented the Internet for communications purposes. Later, it became a tool of kinship ties and sharing of information among mankind. ICT is arguably the most powerful tool in human civilization development. Modern man keeps in touch with Facebook, Twitter, and e-mail, which means such technology generates great influences to our civilization.

To progress with the field of ICT, a special location like Silicon Valley in America, a site named MSC was developed in Malaysia, located at Putrajaya and Cyberjaya. Its function is similar to Silicon Valley; this place is designed to develop the ICT facilities. High-speed fiber-optic facilities are provided in full. ICT multinational companies such as HP, Dell, and Microsoft were brought in to invest in this area and conduct research and development for Malaysia to achieve the modern status of ICT in the modern world. The increasing amount of research and development in ICT is causing an increasing demand for workers with ICT literacy among Malaysians. Hence, the government introduced the

subject of ICT in school, aiming for increasing ICT literacy. It is made an elective subject for encouraging students to learn ICT. Computer labs are available in schools to facilitate student access to ICT. Special Wi-Fi is also available in a particular school for that purpose. While many ICT facilities are provided, there are still some deficiencies in the process that led to the failure of implementation of ICT projects in schools.

To ensure that all students achieve Internet access facilities, the government has provided Internet access and a phone line in some public schools. A smart net program was also launched in all schools. The program was launched in partnership with the government and private companies to provide broadband services for all students in the school compound. Each student is given a special account with a password. They can do their learning through this account, and the homework and learning notes can be uploaded in this account for teachers' review. In this service, the private company is responsible for providing the signal transmitter and wireless Wi-Fi antenna on the school grounds. Through a signal transmission antenna, the school can access Internet instantly by using netbooks and laptops. Students can study in any spot in school without the presence of teachers. Teachers can implement the lessons without face-to-face interaction or dealing with students. This scenario seems quite advanced in modern times, a great leap forward in Malaysian education.

This approach is modern enough to improve the education system. But the government needs to address some problems to ensure the program runs smoothly. First, the school faces a shortage of experienced ICT teachers to assist students. Most teachers in Malaysia are only trained in the natural or social sciences. Familiarity with ICT knowledge is not emphasized in teachers' college training. The government continues to use the old method to train schoolteachers who become skilled in teaching theories only. This scenario resultes in an increased number of regular teachers at the school, and the teachers who are ICT literate or technical become fewer in number. ICT training is less emphasized in such processes, causing insufficient manpower of ICT teachers. Just

imagine, sometimes less skilled teachers are asked to teach ICT. Does the teacher teach well? Does the teacher deliver ICT knowledge to students? In this author's opinion, this indirectly insults teachers who teach such subjects in school. The community will see teachers as incompetent in the field of education. There are teachers who are trained in ICT, but not many in number, which means only one to two teachers are trained in every school. An ICT teacher must teach almost all classes in the school. Just imagine the gravity of an ICT teacher workload.

To ensure that students are mastering ICT, ICT teachers should be sufficient. In addition, computer labs and facilities should be adequate to accommodate the number of students who are increasing yearly. The problem is the number of computer labs in schools is insufficient compared to the science labs. Typically, each school has approximately ten science laboratories. However, only one or two computer labs may be available at the school. The small number of computer labs is not enough to accommodate that many students. Furthermore, the number of computers is not enough for students. Just imagine a computer lab that has only thirty computers. Is it able to accommodate the size of a class with thirty to fifty students? Of course not. Sometimes, teachers have no choice. They are forced to teach theory because of the lack of computers. How could this scenario improve students' ICT skills? As a reader, try to imagine it. Well, the government is supplying the latest computer models to computer labs. Some technical problems have not been fully solved, such as hardware and software maintenance. This process is important because it ensures the computer's smooth operation. At school, computer maintenance is almost ignored because no technician is appointed for this matter. This causes the computer lab to not operate smoothly, thus obstructing students' learning. The school may be able to call a technician from a private ICT corporation. But it involves more budgets, which may increase the financial burden of the school.

To overcome the lack of computers in the lab, students are encouraged to bring their own laptops from home. Laptops or netbooks

can be used in ICT classes for the learning process. The problem is that not all students can afford the cost of expensive laptops. Only wealthy students can afford to buy laptops. How about students from poor families who want to get more money to buy laptops? This is an issue that should be resolved before the government's ICT program implementation in schools achieves its goal. Indeed, the government is providing free netbooks to schools, but it is limited to certain schools. Not all students may be able to gain netbooks from the governments. Urban students can indeed be easy. How are the students who live in rural areas? It is hard for governments transporting netbook supplies to them due to obstruction of the fluctuating geographical landscape. Some rural areas are not reachable by road and river. This is certainly an inconvenient delivery process. Such situations cause uneven netbook distribution among Malaysian schools, especially in rural area.

Another problem arising from ICT learning in Malaysian schools is that not all schools in Malaysia have Internet cable connection and broadband networks. City schools have full Internet service and modern ICT equipment such as fiber-optic cable and wireless networks for Internet access connection. How are the rural areas? Indeed, rural areas deal with less efficient Internet connection due to the absence of fiber-optic cables. Rural residents may be able to use wireless Internet in their villages. However, the lack of wireless antenna towers makes it difficult for them to use the Internet. Internet towers are built in the city more often than rural areas. Particularly, rural schools are a facing shortage of Wi-Fi towers. How do the students there study the ICT lessons? The school is not connected to a telephone line, fiber-optic cable, and Wi-Fi. So, ICT programs may not be carried out successfully in rural areas and thus reduce ICT skills among rural students.

9

School-Based Assessment Controversy: Does a Student Learn?

Malaysian education is adapted from British education, where its education is more exam oriented in implementation. During the British colonization era, the English primary schools and secondary schools were constructed. Their purpose was to train the locals to become government servants who assisted the British administration. Those who received an English education would be granted the opportunity to work in the government department as low-ranking officers, such as police officers, administrator assistants, and tax collectors. In order to get a job in a government department, which guaranteed a good carrier prospect such as guaranteed pensions during retirement, the locals preferred to send their children to English schools rather than letting them work at the farm plantation, which had to endure great hardship. During the colonial era, job opportunities were fewer, and the locals did not have many choices either working as government servants or on farm plantations. The English secondary schools required the students to pass an exam known as the MCE (Middle Cambridge of Education) before they were accepted to work in the government sector. During the colonial era, this exam was considered important because it guaranteed the student a job in government or furthered higher education in the United Kingdom. After independence from the British, the new government used the same education system inherited from the British

colonists. This education was more exam oriented. In the British point of view, the examination was the best way to evaluate students' academic performance before an academic certificate was granted to them. The new government transformed the MCE exam into the SPM exam. The SPM is known as the Malaysian Education Certificate, which is equivalent to the O-level in the United Kingdom nowadays. The SPM exam is almost the same as the MCE in its syllabus and exam format. The difference lies in the medium of instruction—that is, the MCE is conducted in English, whereas the SPM is conducted in the Malay language.

Modern Western society, such as in the United States and Europe, seldom uses such old-fashioned ways of assessing or evaluating students' academic performance. Those countries are using school-based assessments to replace exams. So the Malaysian government is deciding to adopt modern ways of academic evaluation. The purpose is to transform Malaysian education to achieve international standards such as implemented in the United States.

The school-based assessment implementation started in 2006 when it gained approval from the education ministry. The implementation started completely in 2012, which means the Malaysian public schools are not dealing with examinations anymore. All students have to undergo the school-based assessment. Students will be given assessments throughout the year using the method of homework, modules, worksheets, group discussions, presentations, and projects. There are two types of assessment, school-based and centralized, where teachers will evaluate the school-based one and representatives from the ministry will assess the centralized one. Marks granted are not based on how well the students are answering the questions; they are based on how well the students express and describe their point of view confidently. The students who write well may get good marks. Those who write well and present well confidently will be granted higher marks. Extra marks will be given to students who write and present well and, at the same time, stay active in

outdoor activity such as sports. The purpose of school-based assessment is to train students to excel in every field of knowledge. This is how the new school-based assessment applies in Malaysian public schools.

Such an assessment method received good responses from society at first. They believed such assessment could reduce the burden of homework among students. In their point of view, students would no longer be able to memorize the facts for an exam. In contrast, the students are given a chance to express their personal potential fully in academics. Students would no longer deal with stress caused by exams. Some students who get poor exam results sometimes become unconfident in their studies; thus, they drop out from school. Exams have also caused certain students to commit suicide due to the fear of getting poor exam results. It is a great lost to human capital development in Malaysia.

The assessment approach has also received positive response from educators, especially teachers. They believe that school-based assessment could give students a chance to express themselves according to their personal talents because every student is granted certain specific talents in their lives. Developing their full personal talent can bring out the best in them. Parents believe such an approach could reduce stress arising from unnecessary competition, especially comparing the exam grades of every academic subject, thus reducing the exam overemphasis in determining students' worth.

The government launched a campaign about the importance of school-based assessment to society. Conventional media such as satellite television was used as a political tool to broadcast how excellent such a method is. But the reality is that school-based assessment created a catastrophe in Malaysian education. Such an approach did improve students' learning psychology and lack of stress, but it also created a decline in students' academic performance. With the exam abolished, how would teachers evaluate students? How would teachers know if the students had mastered the concept that had been taught? Because students are given a chance to open the book or access the Internet in

the assessment process, they may blindly copy the information from resources without thinking twice about what they ha learned. They may just present the information in front of classmates without knowing in detail what they are really learning. Students would also be evaluating in theoretical aspect using the homework they have done. The assessment using the homework is not fair enough for all students because some may copy the answers from their friends. How can the teachers fairly assess them if all the students have the same answer—and the same handwriting? This copycat action in education surely cannot differentiate who does learn more in schools. Should the teachers give As to all students or let all of them fail? It becomes a question that requires readers' deeper thinking.

Such an approach is less transparent in its assessment process, and it has another problem that it has to deal with bigger class sizes. As we know, the Malaysian public schools are very crowded with students; each classroom has to accommodate about thirty to fifty students. The crowded class environment is surely hard to make school-based assessment work well in reality. Just imagine a classroom with forty students where each student has to do his or her presentation for about fifteen minutes. Can the assessment be completed within a day? Of course not. It takes about a whole week, maybe a month, for all students to complete the presentation. A lot of time has been wasted just for certain academic topics.

What about the teachers? The teacher will give marks in the process, but he or she may have insufficient time to teach for finishing the syllabus. It is a nightmare for both students and teachers. For students, they have to spend a lot of time for preparation, whereas the teacher is dealing with insufficient time for teaching. This approach is only suitable for Western country schools, where their class size is about twenty students.

The school-based assessment does create some inconvenient situations for teachers and students. How about society's response? At first, the

society received it well. But gradually, they turned against it. They felt upset due to inconsistency of school-based assessments. Some schools will provide tougher questions, and the other schools are providing easier questions, which means the assessment method is invalid in evaluating students' performance. The assessment grade for every form will be kept classified until form five (upper secondary). Then the students will get their final academic results at form five in the form of a certificate. That means the students cannot get their real academic results every year, yet they have to wait for it until finishing secondary schooling. Usually, the parents are eagerly looking for the academic reports of their students. But the schools cannot provide it because the academic results remain top secret in administration files. Sometimes, the school itself is forced to hold a secret internal exam without informing the ministry in order to fulfill parents' requirements—that is, the exam results. For parents, only the exam results will show how well their children's academic performance is at school. Most of the parents will feel offended if they failed to get it. Such a scenario shows how ineffective school-based assessment is.

Because of lack of transparency in school-based assessment, it becomes a controversial issue in modern Malaysian society. Local media portrays it as "confusing tools" in education, which means it creates great confusion in society. The teachers and students do not really know what they are doing in academics, and society itself does not know what the real academic performance of their children is. Malaysian education turns illusions for all of them. Even though such an assessment method is controversial, the government pretends nothing is happening at all. The society lodges many complaints, but there's no further action or solution from the government. Some promises have been made to improve it, but at the moment, no action has been taken at all. Fearing such illusions, some parents are willing to send their children to private or international schools, which are using different approaches of assessment. The parents believe that such moves will solve the problem instantly. They have

to deal with new problems such as expensive school fees. The rich can afford it. How about the poor? Surely, their children will become the genuine pig of inconsistency arising from ineffectiveness of school-based assessment implementation.

10

Vision School and Cluster School Project: Is It Improving School Quality?

The education ministry launched the education development plan in 2006, which lasted for five years and ended in 2010. Under the great education plan, the ministry was trying to do some things that could improve the Malaysian education system. The purpose of these improvements was to enable more students to get equal education and thus reduce the school dropout problem. In line with the policy of Malaysian education democratization, the ministry gave the dropout problem priority to improve the education standard. Some aspects were given full attention such as a sufficient number of teachers, classroom size, and the school ICT facilities.

This aspect of quantity became the ministry's main concern. Not to mention the quantity, quality was also important to ensure the concept of education democratization. The quality of education—teachers, the ideal learning environment, and effective school management—had to be considered for developing the national education system toward an international standard. One of the quality aspects that should be emphasized more is how to manage the school effectively. That is, the ministry launched two special projects such as the vision schools and cluster schools. The extraordinary management methodology had been used to ensure the quality of a school.

For the reader's concern, the ministry implemented a vision school project. Vision school is made up of a three-type combination of national

schools and national-type schools. The national school consists of the Malay school, while the national-type schools are comprised of Chinese schools and Indian schools. All these schools use a different language of Malay, Chinese, and Indian as the medium of instruction in school. The schools use their own mother tongue as a medium of instruction. Different principals administrate all the three schools, even if it is grouped in one area. The schools also share common basic facilities such as playgrounds, sports fields, and a canteen. In the learning process, students do not mix around. They are learning in the classroom. During breaks, they will go to the canteen for having meals together. In the sports or extracurricular moments, students of the three schools will use the same football field for sports activities.

Why are these three types of schools combined in a common area? The aim is to overcome the lack of basic amenities experienced by Chinese and Indian schools. As a result of this combination, it has spawned a new vision school concept. The combination of these three schools makes manageability school turns easier because all three school administrators work together to overcome the problem of comanagement. This project is believed to improve the administration and management system in Malaysian public schools.

Another project that is believed to improve the school management is known as cluster school. Unlike the vision school that consists of a combination of three types of schools, cluster schools consist of only one type of public school.

What is the most significant difference between the vision school and cluster school? The cluster school has to accept students based on the examination results, such as students who have six As in the UPSR (primary school standard assessment). Only the selected students will be accepted in enrollment. This is one of the most important features in the school. In terms of administration and management, principals are given autonomy in the process of recruiting teachers, school finance fund-raising, and only selecting the best students for school. The school

is allowed to carry out extracurricular activities freely. This means that the school can establish associations—that is, clubs that are not on the ministry checklists. Autonomy granted to the principal aims to get rid of bureaucracy experienced by public schools. The school is also allowed to offer subjects that are not on the syllabus of the ministry— for example, music, photography, liberal arts, and acting. Principals are given the autonomy to recruit foreign coaches to train students in sports. In financial terms, the principals are free to collect money from people freely without having to get approval from the ministry or education department. Private companies are allowed to work with the school in the development of education through charity donations without having to negotiating with the ministry. These are some of the special features of these schools that will improve the administration quality and thus avoid a messy bureaucracy.

Many excellent figures have been trained by a vision school. One of the advantages that authors applaud most is that these schools can unite Malaysian society, which consists of various races, and create a spirit of brotherhood in Malaysian society. For example, in the vision school, all three races cooperate in the sports arena such as football tournaments. They will play hard in football competitions. The spirit of sportsmanship, such as teamwork, exists in every member of the team that consists of different ethnicities. The spirit of sportsmanship, which became a major stimulating factor as an incentive to succeed in the competition, will go beyond the spirit of the team that consists only of a single race. So, not surprisingly, the vision school always achieves champions in any sport competitions.

On the academic front, the spirit of cooperation can be fostered between the three races. They sit together in lesson revisions and academic problem solving through group discussion. Knowledge sharing between civilizations indirectly happens between them because each race has its own special knowledge passed down by its ancestors. Sharing of knowledge will add to the diversity of knowledge in Malaysian society, producing a superior civilization in the future.

After we discuss the vision school, we will study the cluster school in detail. What advantages are there in these schools compared to regular public schools? The advantage is that this school is free from absolute command from government or bureaucracy administration. This means that school administrators are free to make decisions based on the discretion of the principal. In this case, the principals are given the autonomy to make certain decisions, particularly the recruitment of teachers, student recruitment, financial management, cocurricular activities, and community activities. Principals are free to decide the matter without the need to refer to the ministry or department that requires bureaucratic approval. This helps reduce extreme bureaucracy in public service. The workload of all parties can be reduced indirectly. In terms of recruitment of teachers, cluster schools are free to choose the expert teachers from other disciplines to teach students immediately. It shortens the time taken for recruitment of teachers conducted by the ministry in which it took many years in process, which might create a shortage of teachers.

How is the students' intake? The principal is free to choose the most outstanding student in the country to enter the school. He or she has the authority to reject the application of any student who is considered unfit. Even the student himself or himself had to protest at the ministry.

With some autonomy granted to the principal, he or she is free to plan activities that are considered most suitable for the development of cluster schools as well as propel the school to greater achievement. In extracurricular activities and sports, the principal is free to organize activities that are not in the ministry guidelines—for example, public speaking, acting, concerts, cultural festivals, and bands. The school budget is a large issue in organizing these activities without having approval from the ministry. Arguably, these activities are conducted almost every month in the cluster school. Students are given the opportunity to plan, organize, and participate in the activities under school supervision. Teachers act as consultants or facilitators in guiding

students in extracurricular activities. Many activities are organized to meet the needs of the school. It provides opportunities for students so they can perform their talent and thus expand the potential of every student. In this case, outdoor learning is more preferred than a traditional learning method. It is a way to make students learn faster and mature in solving daily problems, thus making them more self-reliant when dealing with the society.

Other than autonomy, the government also provided substantial allocations in the development of these schools compared to regular public schools. Provisions are needed in the organization of activities. Also, the development of basic facilities is required for the activities such as a special hall for organizing formal occasions for public speaking or academic presentations and computer labs equipped with broadband facilities for ICT learning and computer programming. These facilities are very important for cluster schools that focus on extracurricular activities. In a regular public school, the facility is actually there, but it is insufficient to accommodate the number of students, which is too many. But in cluster schools, although a lot of students are there, the development of these facilities will be given priority so the activity runs smoother. These facilities will facilitate the effort of students and teachers. Moreover, almost all the students of these schools are excellent students and free of disciplinary problems. Discipline is not an issue here. Students with good discipline will use this facility properly. Vandalism would not exist. Students would take good care of this facility because they realize the importance of facility usage for extracurricular activities to rise up the school's honor and the country's reputation at the international level.

Although these schools have certain advantages that are not owned by regular public schools, they still have some problems that school administrators must face. In theory, these schools are given autonomy in administration; however, in reality, they do not have autonomy. The administrator must adhere to the instructions of the ministry in the implementation of education policies such as the education development

plan, mathematics, and science in English. Like it or not, the principal has to make sure all teachers have implemented the policy. The principal has no authority in choosing the medium of instruction in all academic subjects. In line with the government's policy to use the Malay language as the national language, it is used in learning. International language such as English is not allowed. The ministry had launched the program of teaching science and mathematics in English. That is, both of these subjects can be taught in English, but the Malay language is not allowed in using to teach such subjects. The principal cannot do anything because this is the absolute order of the ministry. For the reader's knowledge, principals are given the freedom to get donations from the community without having to get the approval of the department or ministry. For the author, this is good because it can reduce the bureaucracy. However, the principal did not have the authority in implementing school development planning. The school development plan must get ministerial approval before it can be implemented. Where is the autonomy that the ministry promised?

The cluster school is a new concept introduced to the Malaysian education system, but this concept has long been established by Western society fifty years ago. To implement this project, school administrators and teachers should be given special training on the ins and outs of the cluster school concept. But it is not done. The educators should be given special training on cluster school concept, implementation method, and the ways to effectively manage these schools. But they just receive the usual briefing only. They are not exposed in detail about what these schools are. Many principals and teachers do not understand what the concept of cluster school is. They just execute commands blindly from ministries until the cluster schools look no different from a regular public school. The only difference is the student. When the teacher is less clear about his or her goals due to lack of training exposure, then there is a problem of quality. Quantity is the students with outstanding exam results. How about the quality? It is still using the old method of

bureaucracy in the administration. The absence of better quality always angered parents because their children cannot get the best from school. The ministry does not care about it although receiving many complaints from parents.

Regarding the lack of quality instead, the quantity stuff is more than quality, not only regarding students, but more time is spent on sports and extracurricular activities, ostensibly to get a gold medal for the school. For the reader's concern, the school principal has the authority to organize any activities other than the activity in the guidelines. The principal is free to plan and implement sports and cocurricular activities without having to get approval from the ministry. This situation burdens the school with activities every day. The nonacademic activities indirectly interfere with the learning process. The students will not be in a classroom all day. They are on the football field or assembly hall to prepare for the activities and competition. Sometimes, maybe only half of the students stay in the classroom for learning. Students who are not involved will be studying as usual. How about the students who get involved? A lot of time is wasted for activities, so should students who are active be given extra classes to substitute for what they leave behind in their studies? Of course not. Students can certainly enjoy the extracurricular activities, but the academic learning is disrupted. Such a situation causes their results to decline due to lack of learning in the classroom. They may be able to get many gold medals in sports competitions and activities. Instead, the exam results deteriorate eventually. Isn't that a great derogatory statement to the implementation of this project, which aims to boost academic excellence and eventually lead to the decline of students' performances themselves?

Not only are students experiencing academic performance degradation problems, teachers in these schools also deal with a disastrous problem, namely, the increasingly heavy workload caused by the frequency of extracurricular activities. For the reader's concern, teachers are burdened with the job of teaching and filing paperwork.

The planning and monitoring of extracurricular activities intensifies their jobs. Won't it skyrocket the workload of teachers? The main task of the teacher is teaching, but they are burdened again with such activities. Sometimes, it results in absences of the teacher in the classroom. They simply just want to carry out activities with the students. The monitoring neglects the teaching process until students in the classroom do not learn at all. Some also come together to participate in activities organized by the school during the time of teaching. Such scenarios result in loss of control of the classroom. It creates a very noisy classroom condition in the absence of teacher control. This is a weakness of these schools, which are more preferential to school activity achievement. That is, these schools make the teachers' burden heavier. Teachers can't stay in two different places at the same time, right? In terms of time, the implementation of activity is inappropriate. The activities are carried out in the morning, overlapping with teaching sessions. Actually, these activities should be carried out in the evening, which is free from teaching sessions. Several scenarios discussed lead teachers to ask for transfer to another school due to the extreme workload. Finally, some of the teachers in cluster schools asked for resignation. Principals have to spend more time conducting interviews to recruit new teachers. The declining number of teachers could pose a negative impact on the students, which may create great losses of education experts who are useful to them.

11

Financial Allocation Inequalities

The financial allocation for education is a sensitive issue in Malaysian education. It always becomes a main issue for intense debate during the annual budget presentation in Malaysian Parliament. The ministry of finance does allocate a certain amount of funds for the Malaysian education development each year. The education sector receives the most in an annual budget because education requires a lot of money for its implementation, especially in paying educators' wages and preparation of education facilities. The funding of education requires proper financial planning because it involves many things that the government has to deal with, especially the ministry of education; it has to face a large number of civil servants and students. All of this involves financial management other than human resources management. We can conclude that the education ministry indirectly acts as a gigantic organization among all Malaysian ministries because it has to deal with a lot of regarding the large student and educator population. Because human resources is bigger than other ministries, it requires a larger financial fund in its expenditure. So, financial management is much emphasized, from the ministry level to the school-based level.

Financial allocation management is very important, especially in Malaysian public schools, which involve national schools and national-type schools. Both of these schools receive direct funding from the education ministry after gaining approval from the finance ministry.

The fund is granted in a lump-sum approach. The school principal as an organization manager will be using the granted funds for school facility development, such as purchasing teaching aids. That means the school principal has to plan properly in spending money wisely for a school. The excessive spending is not allowed because the school is only granted a fixed amount of funds every year. If the principal spends more than the allocation, he or she has to look for other financial resources. But the principal's authority is limited. Before he or she spends the money, he or she has to submit a proposal to ask for approval to spend the money from the education department. Proper planning is required in school financial management because it involves several aspects in school development. Almost every aspect requires expenditure and starts from stationery and teaching aids and leads to purchasing of chairs.

Although all public schools receive financial funds from government, using the same financial management approach, all Malaysian schools have to deal with one more serious matter, financial allocation inequalities that cause ineffectiveness in school administration. As we know, the education ministry granted each school a large amount of funds, but the issue is the allocation is unevenly granted to both national schools and national-type schools. The national schools gained more financial allocation than the national-type schools, at least 50 percent more. That means the national schools get larger funding than the national-type schools. It can run effectively without worrying and dealing with financial problems. The larger funding is more than enough for school infrastructure development. The principal himself or herself does not need to have a headache over how to accumulate more funds from other sources. The financial problem is not really an issue for a national school to worry about. If there is a financial problem, the school still can ask for help from teacher and parent associations that are established at each of the national schools. This organization has its own objective that is helping school administrators to manage the school. Also, it encourages cooperation between the school and parents. The teacher and parents

association has its own fund collected from parents' donations where the school administrator can use it if there is any insufficient expenditure arising from managing the school.

How about the national-type school? It is an insult that this type of school, although classified as public school, does not gain the full financial support from the ministry. It only gets half of the allocation compared with the national schools. The teachers in this school are government servants, but a board of directors supervises the management of the school. It is not fully under the supervision of the education ministry. By using such reason, the ministry does not give full financial allocation to national-type schools. Is it rational for the ministry to do that? Such decision is causing problems to this school because the school administrator himself or herself has to deal with the problem of insufficient budgets for school development. In order to gain more allocations, the school has to gain more funds from society through fund-raising or donations. It is quite troublesome for schools because more work has to be done to collect extra funds for school expenditure. The unfair act of the ministry is causing such an inconvenient scenario that the national-type school faces. Aren't both types of schools public schools? Why is the treatment so different?

How about the financial allocation for private schools? The private school does not receive any financial allocation from the ministry. This school has to runs on its own effort in collecting funds for school development. The fund is gaining through the collection of school fees or donation contributions from society. This is how private school survives in Malaysia. To survive, the private school has no choices. It has to collect quite expensive fees from students for its development expenditure. Other than fee collection, the private schools have other approaches in dealing with insufficient funds such as business collaboration with society. This collaboration is important because it guarantees continuous financial funds channeled to school, which is a kind of smart cooperation between school and society. Sometimes, the government does give some donations

to private schools. This kind of action will only happen during election seasons, especially for gaining the political support from the society. Such political donations given seasonally are certainly not enough if compared with other sources. Usually, the private school is not interested in this kind of political donation. They just accept it as a kind of official matter rather than as a kind of financial aid. For them, using an independence effort is better than political aid.

We know that private schools do not receive financial allocation from the ministry. How about the religious school? It does receive some financial support from state government compared with the public school, which the federal government controls. The financial support from state government is not much because the state government does not have much income compared with the federal government. This scenario causes the school to deal with financial problems where they lead to obstructed school development. Malaysian society is not interested in giving donations to religious schools because the government does not recognize its certificate. Fearing for their children's future, society itself is not interested in sending their children to this type of school. Because there is no future entering into this school, society is not interested in contributing money for this school development.

Sometimes, the media portrays this school as a nest for training religious extremists. Such unfair reports surely will fear the society. There are parents who send their children there, but just for spiritual purposes, not for learning. So the religious school ends up with the undeveloped facilities such as old buildings where their conditions are not safe for students to learn inside.

The uneven distribution financial allocation is certainly unfair to Malaysian society, where one side of society gets more, but the other side of society gets less even though all the society members are taxpayers. That is a greater gap of education in society, leaving this uneven distribution of financial allocation. The government itself is not interested in solving such problems although it receives several complaints

from public society. In the government's point of view, the authority of national-type school is not fully in control by the ministry. Why should more allocations be granted? Such ungenerous acts can cause financial burdens to schools.

In order to solve the problem, the NGOs play a role in fulfilling this broad gap by providing some donations to the national-type school. Their main concern is to reduce such financial burdens to national-type schools. Other than donations, the NGOs also cooperate with this type of school in fund-raising, especially in small-scale businesses and entertainment carnivals. Society responds actively in these activities because they know that education is very important to their children's future. A quality school needs better financial funding from them. They will try their best to be involved in the activities or donate in the fund-raising for the benefits of their children's future.

Finally, the issue of uneven financial distribution in Malaysian schools caused by irresponsible politics remains a challenge for Malaysian society. All parents have to deal with it because they have children to send for education. Education is their children's future. Can you just imagine if the fund is insufficient in school management? What will happen? Our children might not learn properly because they have to face the problem of insufficient teaching aids, chairs, and tables that are essential to the learning process. We cannot expect our children to sit on the floor in the classroom without the whiteboard as a teaching aid for learning in a teaching session, can we? The old school building with rotten pillars needs to be reconstructed to ensure its safety for students. Because of insufficient financial funds, the building cannot undergo any proper construction maintenance. Surely, this will threaten the students' lives. We, as parents, have to pay full attention to this issue to ensure our children's safety. We should learn from history where there was a teacher killed because of a collapsing old school building in Malaysia.

12

Spread of Bullies, Gangsters, and Triad Society Influences in School

Disciplinary control management is very important to any learning institution. Since the existence of schools, especially in the era of ancient Egypt, the disciplinary control for students was emphasized by educators so their disciples could learn more by focusing on academics. The focusing process in learning can help the student himself or herself to gain more from his or her masters. Hence, it is the main purpose of implementation of disciplinary action in schools. There are several ways to impose disciplinary action to students to make sure they learn better or behave in a good manner. For example, in ancient Egypt, the students would be caned by teachers using a wood stick if they could not perform the reading properly. In ancient Asian civilizations such as China, India, and Japan, the students would be caned by using rattan if they committed serious offenses such as being rude to the elders. In modern American schools, students would be put in class detention if anyone had been bullying the others. Basically, those are the ways that humans have used to enforce disciplinary rules in school in order to protect the interest of all students in school.

The English school was established during the British colonial era as a public school, where it accepted students from all races in the Malayan Peninsula. In that era, disciplinary management in public school was very strict. The school administrator appointed a special committee, a

prefect board, where its members were prefects appointed from chosen students and educators. The principal granted the prefects the authority to supervise the students' discipline. For example, the prefects could cane the undisciplined students if they had disobeyed disciplinary orders. During that era, all students were very fearful of the school's actions when the principal ordered troublemaker students to be caned by him or her in the weekly assembly located at the school's assembly hall. Because of the strict disciplinary action, almost all students were very good about obeying rules and regulations of school. Fighting, bullying, and gangsterism hardly happened during that era. A little bit of truancy might happen. Such small matters would not threaten the other students much if compared with serious offenses.

Gradually, English public schools abolished the approach of caning and beating. The caning was abolished because it was protested by human rights activists for being a human rights violation. The merit-demerit system, a form of point deduction or increment, replaced it. It depends on how serious the disciplinary offense is. The serious offenses get higher point deductions, whereas the moderate offenses get lower point deductions. The students who get a certain amount of points are given a warning letter. If the points accumulate again until a higher amount is reached, he or she is subjected to instant suspension from school. This is how such a system replaced the caning method. The purpose of using this system is to give students a chance to change their attitudes or self-reflect on their wrongdoings. Also, it prevents students from being harmed by unnecessary forces that may injure their bodies. The undisciplined students can compile the merit points by being involved in volunteering works in school if they want to be accepted back after the suspension.

This disciplinary system was carried on by Malaysian public schools after Malaysia achieved independence from the British. It is a psychological approach that is used to help students who are having discipline problems. By right, such a system should make students more disciplined, but the opposite is happening. During the postindependence

era, the society was not that complex compared with today's society. During that era, the society was still simpleminded, free from the influence of violent movies. Maybe such an approach was very suitable in disciplinary control during that era.

But nowadays, society is getting more complex, where crimes are committed every day, as we can read in conventional media. Children now are more easily exposed to violent elements while they are watching television or accessing online games. Such "unhealthy" activities surely will influence their minds and also the way they behave. Those elements could cause our children to become undisciplined due to the violent tendencies they learn from conventional media. Is it useful for schools using the same merit-demerit systems to control school discipline? Such an approach may be suitable for offenders with moderate behavior. Surely they will obey. How about those who have extreme or violent behavior? Is this system useful to solve the problems?

In the modern era, student discipline in Malaysia tends to become a critical issue. The conventional media such as newspapers and TV news report such irritating issues almost every week, especially gangsterism and fighting in schools. Media portrayal shows that school is not the safest place for our children to study. The government always denies it at all costs, claiming that such incidents would not post any threat to others. But the reality is that it does happen. The scene of such serious offenses is vividly portrayed in some video clips that are on YouTube. Those video clips are more than enough to be used as evidence to show how critical the discipline offense in Malaysian public schools is. The society itself gets depressed by such violent action. They bring the issue to government, but to no avail. The government promises to create a special committee for investigating such matters. It is useless because this committee has no power to take firm enforcement action. In contrast, it is only limited with investigative power. At the end of the day, the police force has to intervene for bringing the problem into correct order. Due to the ineffectiveness of the disciplinary control system, the problem becomes

even worse. The undisciplined students are posing a threat to others. Also, they are posing another threat to teachers and principals at the school. The threat such as fighting with teachers and vandalizing teachers' cars and school facilities always happens in Malaysian public schools. Due to the government's cover-up, I think the international communities may not really know what is happening in Malaysian public schools. Surely they will feel surprise with such uncivilized acts by certain Malaysian students. The school administrator does not dare to take any disciplinary action, fearing retaliating actions by those gangsters and triad society. The action of school suspension would not fear the troublemakers. But it makes things even worse. Those troublemakers surely will take revenge by vandalizing the principal's home if any disciplinary action is taken toward them. Such a situation creates an opportunity to triad society. They are exploiting this weakness to expand their influences among school students. There are triad members who disguise themselves as school students who do some recruiting jobs in searching for new triad members on school compounds. Can you imagine how critical this situation is? The school administrator and police failed to take any action due to lack of concrete evidence for prosecution at court. So it is hard to bring those culprits into justice. Isn't it a disastrous nightmare for Malaysian society?

The undisciplined action by certain students, with the influence of triad society, has created another social disorder—that is, the rise of criminal activities such as robbing, rioting, and stealing. The government is always criticizing intensely about the criminal rates in the United States, which violent movies and unethical society cause, but the reality is that Malaysian society is also dealing with the same problems as the United States. In Malaysia, the main factor that creates such social disorder comes from uncontrolled, undisciplined students. The triad society recruits those students for committing crimes, which means a triad society is using them as puppets for their own criminal interests. Most of the adolescents are immature enough in decision making. They are so easy to be influenced by triad society in the recruiting process by

using money as bait. Money or higher position in triad society usually will be used as bait to influence them or make them obey the instruction given by triad society. Thus, this situation leads to mass recruitment of young adolescents into this organization. The triad society is involved actively in organized crimes such as smuggling, robbing, and rioting. Those new recruiters will be manipulated to commit crimes to fulfill the triad society's interest. Sometimes, police fail to do anything because those triad societies have good connections with local politicians. Fearing political retaliation, the law enforcer remains silent.

Such uncontrolled triad society activities surely will cause disasters to Malaysian society. It leads to criminal activities and happens almost every week where the victims are killed because of robbery and rioting. Society is living in fear of criminal threats almost every day. In the international community's point of view, Malaysia is a peaceful country that is free from civil war. The Malaysians should be living in gratefulness, shouldn't they? But the reality is different. Malaysians always live in fear of becoming the victims of crimes. So most of the homeowners have equipment with security gadgets such as CCTV and alarms for their own family safety. Not even the locals, sometimes even the Western tourists become the targets of crimes. Although those tourists lodge a complaint to the government or their own country's embassy, no further action is being taken for solving the problem.

Maybe the reader will ask what the role of the police is. The police are doing their job, but they are dealing with a shortage of manpower. Can you just imagine that there is a certain area with more than ten thousand people whom only two police officers supervise? This surely will extremely burden the police task.

Because of society's intense pressure, the government is willing to do something to solve the problem because there was an incident where the burglar broke in a politician's home. A state of emergency was declared for dealing with such culprits. From this incident, the government has learned a great lesson. That is, national security should be a main

concern for administration. The anticrime campaign had been launched to create awareness to society about how critical criminal rates are in Malaysia. Also, the 'Friends with Cop' program was launched to get more cooperation from society with police in combating criminal activities. Mutual cooperation is important in dealing with critical criminal activities. Such programs run effectively at the moment of launching. With the Malaysian population growing every year, society turns complicated, which makes such a program not run effectively anymore. Without the proper follow-up planning and execution of the program, the crime rates rise up again due to gangsterism and triad society. The culprits think the growing population is a golden chance for them to commit crimes because of the lack of law enforcers' supervision. They do take some advantages by using such a complicated scenario.

The increase in crime rates does give a psychological effect to Malaysian society. People always live in fear caused by criminal threats. The adults are getting used to it because they have to work every day to earn a living. How about the kids? I think the kids are more vulnerable to criminal threats because most of them are weak. They still have not enough strength to fight back once they deal with crimes. So, the kids will always become the targets of crime. How pitiful they are. Their parents have to follow them wherever they go out of fear of being kidnapped by abductors. The government's program also fails to reduce the crime rate. Hence, the society itself is not confident in the government's effort in crime fighting until there is a case where a restaurant owner is hiring security officers equipped with pump guns. Isn't that an action that only bank owners will take?

The restaurant owner becomes paranoid because of robbery. It happens although several customers are having their meals inside it. The robbers are daring enough to rob the restaurant even though many witnesses are looking at him. Such a scenario shows how critical the crime rate in Malaysia is.

13

Increasing School Dropouts: Something Wrong?

Going to school should be a great pleasure for children, especially in third-world countries. For them, receiving education is a guarantee of a good future, which means they have better opportunities to look for employment either in government departments or private enterprises. So do their parents. If possible, most of the parents would make sure their children receive quality education because education is a way of improving their social status, especially those who come from poorer families, which would solve the poverty problem. Indirectly, the gap between the wealthy and the poor can be reduced if the education opportunity is provided to all citizens. The modern countries such as the United States do provide equal education to all its citizens. By the implementation of No Child Left Behind by former US President George W. Bush, children from all different backgrounds could get access to equal education opportunities. The Malaysian government uses the same approach where a great amount of funds are allocated for education development for the same purpose. Such a move is supported by society overall. Most Malaysian parents send their children to public schools because they are free of charge from elementary to high school. So education opportunities should not be a social problem for Malaysians, right? Even though all Malaysians receive equal education, some citizens are not willing to receive such an opportunity. They choose to drop out of

school and go for careers without even finishing a high school education. This phenomenon becomes another type of new social problem that is arising in Malaysian society, which turns to sensitive issues that we have to face together.

School dropouts happen because some students are dealing with personal physiological traumas in life. They are dealing with problems of self-confidence, scenarios where they are unconfident in decision making or studying processes. Some are slow learners. Actually, they could learn the same as other students can. Because they are slow, they cannot catch onto what has been taught in school. Hence, the others leave them behind in academic leaning for sure. Such scenarios may be caused by students' cognitive processes, psychological aspects in human beings, which makes them unable to compete with intelligent students. Because their exam results are terrible, society would classify them as unintelligent people. Due to this bias classification, their self-esteem turns lower, making them lack in confidence. They choose to end the schooling earlier because of learning inabilities in school, which makes them feel ashamed when receiving poor examination results.

How about the school environment? It is also a dropout's factor. As we know, the public school is very crowded with students, where each of the classes consists of thirty to fifty students. The crowded classroom creates a very chaotic scenario where the students are talking with loud noise. Also, some are shouting and fooling around with innocent stuff. Two or three students doing this may not be an issue. How about almost all of them doing the same thing? Just imagine how a teacher could control a classroom with fifty students without an assistant. It is a nightmare for the teacher or students who really want to learn.

The crowded classroom creates another incident such as bullying. The undisciplined one who sits at the back would take such an advantage to bully the others. Other than teaching, the teacher is burdened with filing and paperwork. The teachers may not have enough time to supervise the students' attitudes, resulting in advantages by talking to

those undisciplined students. Some of the students feel annoyed by such chaotic situations, making them feel depressed with the uncomfortable school environment. Finally, they feel stressed and cannot learn properly in the classroom. The motivation to learn lessens.

The richer students are willing to pay more for tuition in replacing what they cannot learn properly in the classroom. How about the poor students? They cannot afford it. Some become fed up with education in public schools and finally choose to drop out of school at an earlier age.

Malaysian industrialization turned this nation into a complicated society, where its citizens have to deal with critical dilemmas. It is completely different from Malayan society fifty years ago where it depended on agriculture. The new challenges such as the rise of triad influences and the relative poverty have left significant effects that might increase the school dropouts.

Let's look at the relative poverty issue, especially in urban areas. The urban population has more job opportunities compared with rural. Because of higher living standards, most of the urban population has to work harder to earn more income in fulfilling their daily life expenditures. The cost of living is high where they have to pay for living. Both parents are working daily, ignoring their children at home. The parents do not know whether their children go to school or not. Sometimes, their children also go to work because of insufficient income from their parents. They have to do it to get more income for self-expenditures. The children who are ignored by parents who are busy with jobs in the workplace tend to mix with the triads and make friends with those ignorant culprits. Once they make friends with triads, they tend to be influenced by unhealthy elements such as fighting, loafing, and criminal activities. Those teenagers are young and blindly trust the words of such friends. Such moves make them uninterested anymore in studies, thus leading to school dropouts among urban students.

The critical school dropout rate in Malaysian schools surely leaves certain negative effects, especially the students themselves. Personally, the

student may not receive a complete education, which leads to incomplete academic certificate ownership. Nowadays, many skilled professions such as doctors, engineers, and scientists require at least a tertiary education. If the student does not own an academic qualification such as a university degree, how could he or she get the job with better pay? In the modern age, almost every profession needs tertiary qualifications, where every job seeker has to experience rapid competition in looking for jobs with better pay. Of course, a person could get another job that does not require university qualifications such as hard laborers, plant operators, office boys, and business assistants. These jobs do not require university education as a prerequisite. The only qualification needed is at least a high school certificate. But such jobs do not earn much income in life. The pay may be sufficient only for a personal expenditure. But it is not even enough for supporting a family. The problem arises when those dropouts get married. The occupation income is not enough to feed the whole family. They thought dropping out earlier from school and earning a living was a smart move for solving the poverty hardship. But they are wrong. Once they get married, the poverty hardship arises again and has to be faced by every family member.

How about the effect to society? The citizens with lower levels of education due to the school dropout surely would degrade the entire economy slowly, especially in skilled workers' aspect. A lower education level among dropout citizens means a lack of more skilled workers in helping economic development, where the industries would face the shortage of skilled workers. How could the commerce or industries run smoothly without the skilled workers? The skilled workers are in high demand. Those half-educated unskilled labors could also be recruited in the job market, but it is a disaster to the Malaysian economy. They could do the job as usual. Could those half-educated people perform the job properly in producing a quality product or output for the international market? Because of incompetence from those unskilled labors, large corporations are forced to spend more allocation in providing extra

training to them in order to boost up their job competency and transform them into skilled labor. Other than wasting extra expenditure, it also wastes a lot of precious time dealing with such purpose.

The quality comes out of the production. Could the half-educated dropouts produce better consumer products for the market? Quantitatively, those people are hardworking enough in producing a great amount of output. But the quality of industrial production may not fulfill safety or international standards. Such consumer product surely would leave a hazardous threat to society overall.

The school dropout is creating some social problems to Malaysian society such as relative poverty and crimes. At first, the Malaysian society does not care about it because they think it is not related to them. The society is busy with their work, and they do not have enough time for this matter. What they do is stay busy to earn more for a living. During the postindependence era, Malaysia still can be classified as a country with lower crime rates. It is a peaceful country to live in.

Since the 1990s, the Malaysian crime rate has increased until now, the twenty-first-century era. The academicians, scholars, and intellectuals start to think about what causes such a drastic increase in crime rate and relative poverty. They have published certain reviewed reports in local newspapers. According to their research, the school dropouts are the main factor that leads to poverty, which may increase the crime rate. This finding shook the society, and they started to pay attention to it because their children always received harassment and criminal threats within the school compound. The increasing crime rates alarmed most of the Malaysian parents because their children were no safer in learning in school or walking on the street. If possible, they wanted their children to stay at home after schooling.

It is a misery for the entire Malaysian society. Dealing with such tragic scenarios, the society has no choice. They have to cooperate with police. Most of the parents would phone the police if they found out some students were loafing around their neighborhood during the

schooling session. The police would come immediately and bring them to the police department for interrogation.

How does the government respond to such a critical school dropout issue? The government keeps on blaming the parents for not taking care of their children properly. In a governmental point of view, the parents should be blamed as irresponsible people; they are the ones who are supposed to make sure their children come to school every day because parents spend most of the time with children at home. But the government does not think twice in delivering the speech. In reality, most of the parents are busy with their jobs. How could they have enough time to supervise their children's movements?

The main factor that causes school dropouts is the unconducive learning environment in school, where a classroom is crowded with fifty students. How could the students learn in a comfortable manner while dealing with such a worsening environment? Not all students could withstand it. Some students get depressed with it. They choose to drop out of school and go to the job market.

Gradually, the government is running out of ideas about who should be blamed. The condemnation turns to teachers. The teachers are blamed for not delivering their lessons properly until some of the students choose to end schooling at a younger age. Who should be responsible for the increasing number of students to drop out of Malaysian schools?

14

Solution for a Dilemma

Education in Malaysia is experiencing several problems as a result of excessive intervention from political parties. Political parties have full authority in influencing the Malaysian education system. What is the rationale of doing that? It depends on the reader himself or herself to judge. For the author, this is actually a form of power abuse that clearly occurs in modern democratic society in order to achieve their political goals. They use it for gaining political support from Malaysian citizens forever. The government should intervene in education to standardize education standards. But the political parties did not manage the education system efficiently. They brought havoc to the country's education system. When problems arise, they will blame the teachers and parents. To overcome these problems, I suggest that the politician and society pay attention to the following methodology that it is believed to be more effective to solve the problem. Blaming others is not the best way to overcome such problems.

Improve the Management System and School Administration

First, the government must pay attention in improving management and administration of schools. But how to create effective school management? That is, create less government intervention in the school

administration. Those who are involved in the school administration such as principals and assistant principals should be granted authority for decision making in the field of human resources, cocurricular activities, and the management of financial resources. Power is important because it allows the administrator to recruit expert teachers for teaching any professional subjects such as accounting, art design, liberal arts, and computing. This means that, if the school has no expert in such a field, the principal has authority to recruit experts from the relevant field immediately to teach critical subjects without having to wait for the teachers who are posted by the government. The recruitment process of teachers by the government is bureaucratic. It takes a long time to get a new teacher to teach if the previous teacher retired from public service.

In the area of cocurricular activities that involve sports and uniformed bodies, school principals should be empowered to choose the right coach for training students in sports. Typically, students are trained by a teacher who has no professional training in extracurricular activities. If there is, only a few of them actually know how to handle it properly. Most teachers are trained in academics, and they may not be able to train students effectively. Most schoolteachers have no professional training in the field of sports science and uniform bodies. Typically, students are allowed to train themselves and be led by seniors. Teachers only act as observers. The question is whether this will further enhance the skills of the sport without the guidance of an expert coach. The school students will not be able to become professional athletes due to such a scenario. That causes many athletes not to represent Malaysia in international sports such as the World Cup, FIFA, and the Olympics. So it is important to make sure expert trainers are stationed at each school to train students to become professional athletes in order to compete in international sports. The principal plays an important role in creating a successful sporting environment. He or she should be given full authority in recruiting an expert coach for sports training. Students who train efficiently in sports will compete furiously in international sports.

In terms of financial management, the government is providing full financial support to each public school. Principals will use the financial allocation for the development of school infrastructure. But sometimes, the provision of funding allocated is insufficient enough to overcome the expenses that increase every year due to the increasing student population and rising utility bills. The school will be financially distressed if the provision is not enough. To overcome the problem of insufficient financial allocation, the school has to collect more fees from parents, but the government does not allow this action. The administrator should be given full authority to collect fees. The purpose is to cover increased administrative costs. The government's financial allocation is not enough for its expenditures, frankly. If the school wants to count on community donations, society rarely does so because they thought that the government had given full financial aid. Why make such a donation? To overcome this problem, the school has to hold charity sales for getting more funds. The process of applying for the approval of charitable sales is not easy. It takes quite a long time, almost half a year, to get approval. So the administrator must use other sources to solve financial problems.

Reduce Government or Political Intervention

We know that politics strongly influence education in Malaysia. The government controls almost all affairs in public schools, such as administration, planning, school construction, teacher recruitment processes, curriculum, school financial allocation, school uniforms, school infrastructure, academic subjects, and the examination system. The government establishes special departments such as ministries of education to control all activities regarding the school. All schools, regardless of government and private statuses, have to obey the ministry's policy. Schools that do not comply will be closed, or the license (permit) will be withdrawn. That is, the ministry has the authority in the process

of opening and closing schools. Like it or not, all Malaysians must obey the ministry's instruction.

Nearly 80 percent of schools in Malaysia are government-aided schools. The government has full authority in public schools. But private schools only consist of 20 percent of schools in Malaysia. Private schools have enjoyed a certain level of freedom of intervention from government—for example, the recruitment of teachers, school administration, extracurricular activities, uniforms, and school infrastructure. But at the same time, they have to conform to the system set by the government, such as syllabi, textbooks, lessons, and subjects of the examination system. Private schools are usually better than the government schools for a reason. For example, school principals are free to choose the right teacher specializing in sports or academics to teach their students. With the guidance of the right teacher specialist, then students usually excel.

A unique scenario in Malaysia is that the government is too autocratic in the education system. Principals must obey the government's instructions completely. Principals who do not conform will be reduced in rank or fired. Of course, there are parents who are not satisfied with the inefficiency of public schools. Complaints are usually raised to the school administrator. The principal usually cannot do anything because he or she must follow the guidelines set by the government. Indeed, there are the parents who complain to the ministry. The ministry promises to make improvements, but will the government do anything? The question gets lost in the system, and no one will know about it.

To solve such problems, the government has implemented several new policies, such as science and mathematics in English, ICT in the learning process, and a master plan for education development in the education system. The implementation process occurs too hastily. In my point of view, a special committee should be established to review the effectiveness of this education policy. Without an in-depth study, the policy is implemented even if it gets strong protests from the opposition

party, NGOs, and parents. Finally, a lot of money is wasted, and students' competency doesn't increase at all.

Educational performance declines because the implementation process is inefficient. When a policy fails, the government has to cancel the policy due to rallying protests from the masses. We know the government wants to imitate systems in Western countries, but the change is too drastic. Its implementation must be gradual based on life scenarios in Malaysian culture. The Malaysian students become guinea pigs of such destructive policies, present, and forever.

The formation of education policy in Malaysia is not very democratic because the policies made only involve certain politicians. The general will of the Malaysian population does not choose the policies. The government usually forms the education policy under the ministry of education. The prime minister gives the ministry full authority to form education policy. But who sits on the ministry's board of directors? The education minister and senior government official do. Education experts, university professors, and representatives of parents, NGOs, and teachers are rarely called upon in policymaking. If they are, they give technical advice only.

The policymaking process is not transparent. It causes fewer education policies to be formed in accordance with Malaysian society. This reduces the efficiency of Malaysia's education system. Policies are formed only by the blind tastes of certain politicians based on their political goals, which means education is used to spread political propaganda that reinforces the power of the ruling government. That's their modus operandi.

Other parties should be involved in the formulation of education policies. Teachers, university professors, and representatives of NGOs from educational institutions should be involved in this process because they have vast education knowledge. Their views must be considered in policy formation so policies implemented are not only acceptable to parents but also relevant to Malaysian life. Politicians should not interfere in education

directly. Instead, education must involve people of all levels of society in Malaysia to enhance human capital development for all Malaysians.

Is it rational for the government to control 80 percent of Malaysian schools declared as public schools? For the author, such an action is irrational because the government must bear huge expenses in the process of managing the affairs of public schools. In Malaysia, education is free of charge for students. Students only have to pay some administrative costs, roughly a hundred ringgit a year. This small amount of money is not enough to manage a school even if the government providesfinancial assistance. The cost of managing a school is high because the government is forced to apply taxpayers' money to pay for teachers' salaries, school infrastructure, and utility bills. This requires huge expenses, while it places a financial burden on the government.

The government should release some public schools. Let the government schools be run by other parties so the government's financial burden will be light. For example, the private sector or NGOs could manage the schools. The private sector and NGOs do not have to worry about the financial expense because they will receive money through community donations or the collection of school fees. Schools in developed countries, especially the United States, the United Kingdom, and European countries, widely use this method. Society would donate to the schools as charitable contributions to reduce the financial burden. This indirectly strengthens fraternal relations in the community and the school. At the same time, the community also uses the school institution to take night classes to increase their career knowledge. I welcome this kind of smart partnership.

More Cooperation from the Local Community

Cooperation from parents and the community is certainly important in providing good, effective education for all students as they are part

of the community. They spend more time at home than in school. Parents grant permission for the schools to educate their children in the morning. In the evening, when the children return home, the parents are responsible for their children's care. But most parents nowadays are too busy working, ignoring the responsibility of taking care of their children. They must work a lot to earn money due to the rising cost of living. It is the parents' responsibility to look for money to support their families. Due to busy workloads, kids at home lose out on parental guidance. They tend to make bad friends because they are young and can be easily influenced by their peers. Students influenced by triad society may commit crimes such as theft, robbery, and rape. In addition to committing crimes, the students will follow the "new friends," loafing all over the place. That's why the crime rate increases every year. These criminal activities pose a threat to Malaysian security, notably burglary, snatching, and robbery. Local communities live in fear because of the threat of crime. The burden becomes increasingly heavy as the police have to do more patrols and make more arrests to address the rising crime rate.

What should society do to solve the crime problem arising from neglected students? The answer is simple—that is, cooperation among community members with law enforcement agencies and NGOs. First, through certain NGOs, society can organize specific activities such as motivational talks and religious and charitable activities. Carnivals of sports and leisure activities can provide opportunities for students to spend their time meaningfully. Through these activities, students also have the opportunity to obtain knowledge that can help in their future careers. Indeed, society and NGOs are facing a shortage of provisions to carry out the activities. To solve the problem, the government should provide financial assistance to NGOs so these organizations remain active in guiding young people toward the right path.

Second, police departments also play a role in dealing with criminal activities carried out by students. The police have to work with the community in the Community Policing program. A dialogue between

local residents and police should be held every month to find out how critical the community's level of crime is. Based on the critical crime levels, the police can plan the most suitable measures to prevent crime. For example, they can more frequently patrol high-crime areas, give anticrime talks in schools to encourage awareness of the dangers of criminal behavior, and also urge students to work with the police to prevent crime. The authorities should increase student awareness about the dangers of the country's main enemy: crime.

Gangsterism and triads are two critical issues in Malaysian schools. A special police team throughout the school compound should be deployed. Police will take action against any student who creates gangsterism or is involved in triad activities in the school. School administrators or teachers cannot do anything because they do not have arresting power to prevent such activities from happening. Principals can suspend students, but this is less effective than police intervention.

But what can we do? Malaysia's education system is too "student friendly." Undisciplined students pose a threat to disciplined students. The victim involved usually is a good student. The undisciplined students are granted the opportunity to bully other students and teachers. Ultimately, the principal becomes the victim of undisciplined students' malicious harassment. Apparently, the school disciplinary system in Malaysia needs to be reconstructed to control the wrongdoers. If not, the matter will be a threat for all, including teachers, principals, and other students. Finally, the police have to patrol schools every day to prevent the activities of secret societies from threatening other students.

Undisciplined Students Are Placed in Special Schools

Student disciplinary problems in Malaysia are at a critical level. The rate of discipline problems increases each year, and it is often reported in local newspapers such as the *Metro*, the *Kosmo*, the *Star*, and the *New*

Straits Times. This issue makes more and more people less confident in the Malaysian school system. Many cases of behavior misconduct such as triad gangsterism, fighting, bullying, and stealing are happening in the schools, often requiring police intervention because uncontrolled discipline problems will lead to increases in criminal activity. Arguably, the crime rate is relative to the rate of school indiscipline. It stems from the lack of effective discipline management. But what can we do? The government itself sets the system, using the reason of giving students the opportunity to change, along with the human rights reason, namely the education rights of students. But they did not realize that indiscipline brings trouble to others. Expelled students are given another chance through the education department. They do not have to change their behavior at all. They still practice undisciplined behavior, threatening students and teachers. A student expelled from school five times is still given another chance. The students become more daring in committing disciplinary offenses in school. Thus, school discipline in Malaysia is deteriorating every year.

Students who have discipline problems should be separated from normal students and placed in special schools. If they aren't, their presence threatens other students who really want to learn. This group's presence endangers students' safety.

The school for problem students will give disciplinary talks and moral, civics, and motivational courses to train them to become disciplined citizens. Teachers should be trained to give special guidance to this group. Students in special schools will learn as they would in common schools. The difference is that the students will have to take special courses in the afternoon. In this school discipline is under the strict control of the teacher. If a student dares to act out of turn, teachers would refer the student directly to the police department.

In Malaysia, the Gurney School only accommodates students with disciplinary problems who have been convicted of crimes in court. Arguably, this is a weakness of Malaysia's education and legal systems.

Students who lose control in school tend to commit crimes outside of school. This problem is a critical issue in Malaysian society. Rightly, the school should also accommodate students with discipline problems who have no criminal convictions. The thing is, not many Gurney Schools have been built in Malaysia compared to daily schools. The government needs to pay more attention to this issue and build more such schools to cope with the chronic disciplinary problems.

Special Schools for Students with Different Abilities

God endowed mankind with various skills for having a prosperous life. No one can really master all the skills in the world. Every man and woman must have a skill that can help his or her life run smoothly. Teachers must guide students and develop each student's potential so he or she becomes a successful man or woman. Western figures like Edison, Newton, and Einstein succeeded because of personal talents developed within their personal efforts.

The Malaysian education system does not help students develop their personal potential. Why is this so? All students in Malaysia learn in the same types of schools with the same syllabi, school years, and subjects regardless of whether individual students are slow or fast learners. Students who have special talents are forced to learn with the same syllabus. Actually, students who are geniuses should attend special schools to help them learn at their faster pace without being bound to a syllabus that has nothing to do with them.

Public schools overemphasize theory learning. This method may be relevant for slow learners or average students, but this method actually hinders the learning processes of quick learners and geniuses. If they receive specially tailored syllabi, quick learners and geniuses learn in a more efficient manner. This approach can help these students create new ideas and inventions for the modernization of Malaysian society. The old

syllabus that was focused on theory would hinder their creativity. Just imagine, genius students are left to learn using the conventional syllabus, and they can indeed excel in exams, but this does not help develop their individual talents. They will only act as "robots" programmed to follow protocol, diminishing creativity and innovation available to the individuals. These students should get a chance to develop their talents in special schools such as elite schools, technical schools, vocational schools, and smart schools.

Special schools use special modules or teaching methods and focus more on practical learning. These schools give students exceptional freedom in the learning process. The teacher's role is to act as a facilitator only. Students receive a certain independence to solve problems in school and not just blindly accept the teachers' explanations. At the same time, students are encouraged to give different opinions or create new designs based on theories that they have learned. They are encouraged to write reports or reviews on the topics that they learn about. Students are encouraged to break into small groups and discuss solutions to the problems of academics and create new views. Finally, students have the opportunity to make presentations in private organizations, governments, and NGOs to train the students to be more confident in their learning ability.

It is undeniable that special schools and vocational technical schools do exist in Malaysia. But the number of these schools is significantly lower than the number of daily schools. Vocational schools are offering technical courses for students who are less proficient in learning theory. There are students who are not proficient at learning theory who do very well in the technical field. Due to the lack of government publicity, vocational schools do not have a good reputation in Malaysian society. Most parents still consider Malaysia's vocational schools inferior and only suitable for less intelligent students. Actually, what students in vocational schools learn is about the same as what they would learn in daily schools. What's the difference? Students must take a number of

additional technical subjects in vocational schools to strengthen their skills in technical fields. The government should pay more attention to special needs students with specific talents by constructing schools so these students can develop their talents properly.

Smaller Class Sizes

If you have the opportunity to visit public schools in Malaysia, you may be surprised by what you see. This is because almost all classes in Malaysian schools have enrollments of thirty to fifty students. Just imagine how critical the number of students is. If we compare that to the number of students in a Western school classroom, the number is only about twenty to thirty students or less than twenty people. Can a teacher teach more effectively in a class of thirty to fifty people? Of course not. Teachers may not give adequate attention to each student. Furthermore, the increasing number of students is causing disciplinary problems—for example, extreme noise that annoys students who want to learn. Larger class sizes means that the government failed to build enough schools to accommodate growing student populations. Malaysian populations increase exponentially, while the number of schools has not increased in a linear pattern each year. Can a linear increase in the number of schools meet the exponential increase of the student population? Of course not. This results in overcrowded schools. At the same time, the government did not properly plan school development. Certain areas are densely populated but fewer schools are being built there, while there are areas that are less populated where many schools are being built. Uneven school distribution and crowded schools in city areas make it difficult for students to learn. Indeed, governments often use the excuse of lacking suitable sites for school construction. But this is not a reasonable excuse.

There are several ways to overcome class-size problems. For example, some students from crowded schools can be transferred to other schools

that have fewer students. Also, put more teachers in overcrowded schools. If possible, place an assistant teacher in every classroom to help teachers with classroom control. Assistant teachers can also provide special guidance or coaching that focuses on students who have learning difficulties. The aim is to ensure that every student gets proper guidance. In addition, teaching assistants can help to manage classroom affairs such as student attendance, class cleanliness, finance, and control of students' movements. With the support of teaching assistants, the teacher can focus on learning and teaching of a lesson. Recruiting teaching assistants will, however, increase the government's financial burden; fee collection is insufficient to cover the considerable expenses to recruit teaching assistants.

Special Programs for Troubled Students

Human beings are not 100 percent perfect. This includes students. Students have different levels of intelligence. Each person's ability to learn is different. Some students are weak. Some are slow, and some are fast. This is a major challenge for teachers because they have to deal with classrooms with diversely intelligent students. To make the school-creation process simpler and cheaper, the government just builds one kind of school for all Malaysian students. All students learn the same subjects using the same syllabus.

Is this fair to all students? These actions are irrational and create trouble for students. Weak students will drop out because they cannot follow what is taught in school. Meanwhile, outstanding students must take the same time to finish the schooling as the less skilled students. Actually, students who excel should be able to finish schooling faster than weak learners do. But like it or not, they have to follow the standard period of schooling: primary school (six years), high school (six years), pre-U (two years), university (three years), master (two years), and PhD

(four years). This means they can only complete a PhD study by the age of twenty-nine years old. They could have completed their education at a faster rate if it were tailored to their abilities. In Western society, an exceptional student could get a PhD by the age of twenty-four years old. This is one of the most significant differences between the Malaysian and Western systems of human capital development. Malaysia uses an outdated education system. Does the Malayasian process produce great intellectuals in society although 80 percent of the Malaysian population is literate?

The Malaysian education system needs reforms. For example, not all students should have to fully follow the measures of this education system. The government needs to create a variety of measures that can meet all students' learning abilities. The syllabus range should include a variety of skills such as art, design, presentation, public speaking, liberal arts, photography, literature, and crafts for students with different talents. This is the best approach to develop the potential of each student or to inculcate self-confidence that prevents school dropouts.

In addition to the syllabus, special programs, workshops, and seminars, activities should be established for troubled students, slow learners, and weak learners. The aim is to motivate these students so they build self-confidence and deal with their education problems. If possible, the student should be separated from regular students and trained with a special program. These students may learn better from this method over time. They may change their attitudes and work harder to excel in academics. If they are allowed to mix with average students, their passion to learn will disappear and they may drop out of school. This scenario creates a great loss in human capital development.

Finally, students' performance or achievements should be evaluated using a rating system that varies, skills assessment using observation by several teachers. Traditional methods that use paper tests may be less effective in the modern age. Students may be able to write well on paper, but they may not know what they were learning. They could memorize

the information and may not fully understand what they are learning. To evaluate more effectively, teachers can observe the small projects produced by students in the learning process. At the same time, oral or interview methods assess students on their understanding of the concepts being taught. Students are allowed to make references in such assessments to train them well in the process of finding accurate answers. With the reforms of the evaluation method, it would be more efficient to test the skills of every student more fairly than the traditional evaluation system that uses biased test paper.

15

Conclusion

Education in Malaysia is facing many problems arising from excessive intervention by the political institutions. Society itself is not that concerned with such problems; they talk frequently about the problem, but no action is taken to solve this problem. At the same time, they are just expecting the government to solve the problem although the government is inefficient in solving it, causing the problem to turn critical. The NGOs do not care about it. They cooperate blindly with the government in the implementation of education policy, hoping to strengthen their political influence in Malaysian society.

Because of these factors, the academic performance of Malaysian students is declining every year. If the reader does not believe this, you may refer to Malaysia's ranking in TIMSS and PISA tests. Malaysia's ranking declined gradually almost the same as third-world countries in Africa. Indeed, the government tried to solve the problem but to no avail due to the insincerity of implementation. Will the educational performance of Malaysian students improve in the future? It remains a mystery to all of us. Finally, it remains elusive, once and forever.

References

Brown, Graham. "Making Ethnic Citizens: The Politics and Practice of Education in Malaysia." *International Journal of Educational Development* (2007).

Chiu, Ya-Fang. "Educational Opportunities for Minorities in Malaysia." *International Journal of Educational Research* (2000).

Malaklolunthu, Suseela. "Culturally Responsive Leadership for Multicultural Education: The Case of 'Vision School' in Malaysia." *Procedia and Behavioral Sciences* (2010).

Malaklolunthu, Suseela, and Faizah Shamsudin. "Challenges in School-Based Management: A Case of a Cluster School in Malaysia." *Procedia and Behavioral Sciences* (2011).

Tan, Y. S. "Democratization of Secondary Education in Malaysia: Emerging Problems and Challenge of Educational Reform." *International Journal of Educational Development* (2010).

About the Author

Jeff Tong is an Asian who has lived in Malaysia for about forty years, receiving local public school education for about twelve years with six years in elementary and six years in high school. He had experience with certain unsatisfied hardships while studying in Malaysian public schools. Furthering his tertiary education, he specialized in theoretical science. Once graduated, he furthered his studies in a master's of circuit development. Currently, he is doing his postgraduate research regarding Malaysian multiethnic social culture and works as a social science research officer at a local university. If he is free, social work is his main priority, helping those in need, especially the untouchables who are oppressed by draconian politicians and extremists.